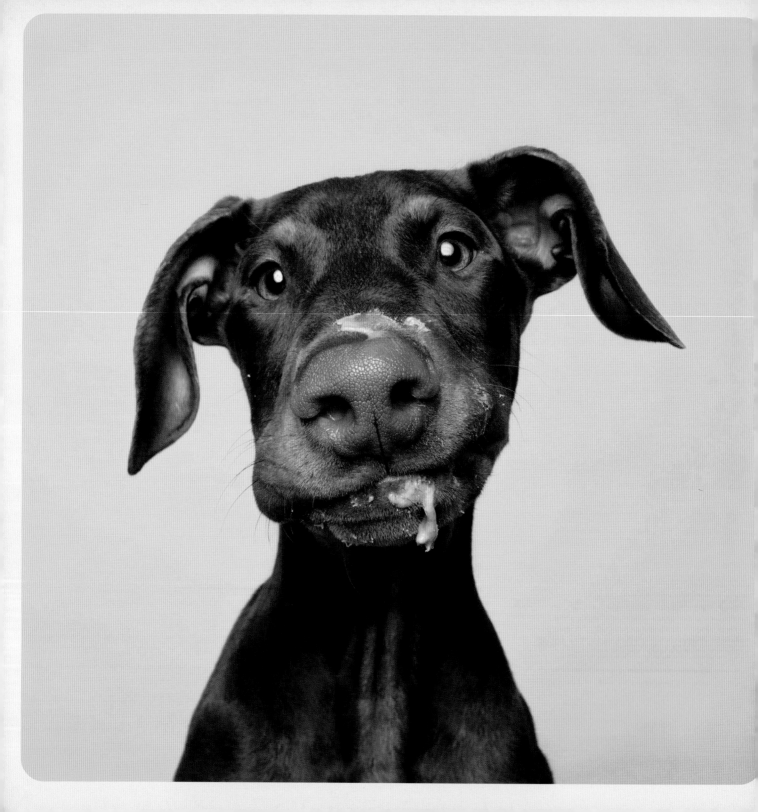

PEANUT BUTTER PUPPIES

GREG MURRAY

GIBBS SMITH
TO ENRICH AND INSPIRE HUMANKIND

First Edition
25 24 23 22 21 5 4 3 2 1
Text and photographs © 2021 Greg Murray

Published by
Gibbs Smith
P.O. Box 667
Layton, Utah 84041

1.800.835.4993 orders
www.gibbs-smith.com

Designed by Tracy Sunrize Johnson
Gibbs Smith books are printed on paper produced from sustainable PEFC-
certified forest/controlled wood source. Learn more at www.pefc.org.
Printed and bound in China

Library of Congress Control Number: 2020941999
ISBN: 978-1-4236-5659-3

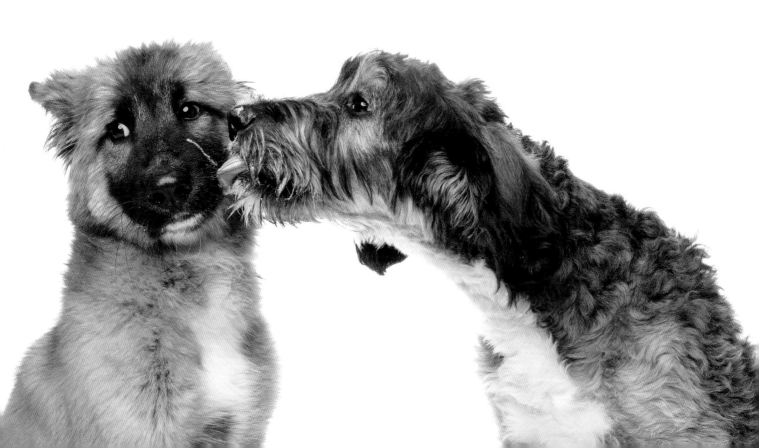

Dedicated to

RESCUE VOLUNTEERS AND STAFF

who work tirelessly to save the lives of

ANIMALS AROUND THE WORLD.

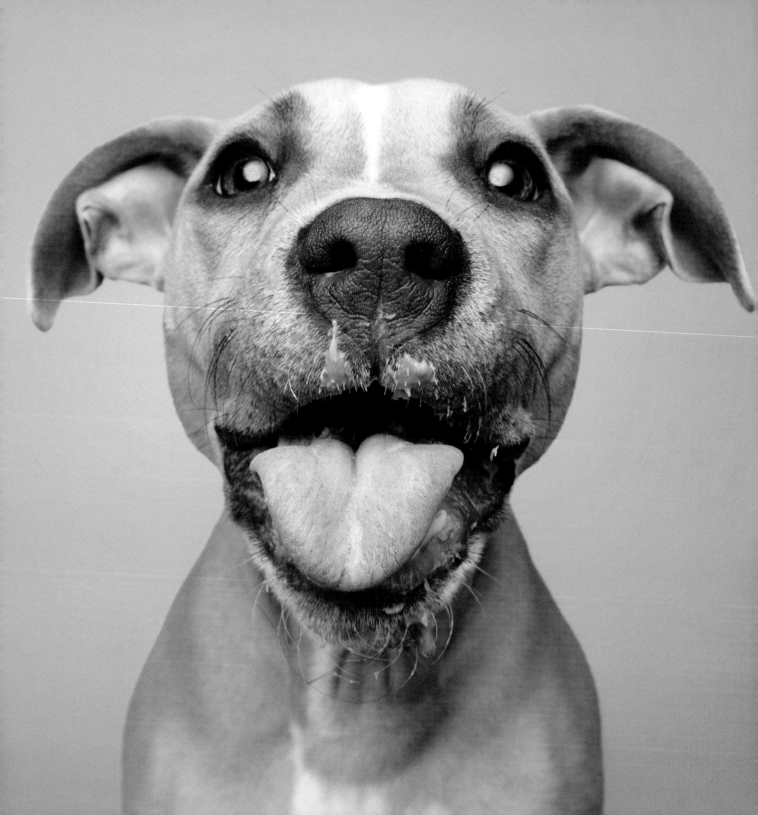

CONTENTS

INTRODUCTION

IN EARLY 2014, I began taking photos of Bailey, our rescued cane corso, eating peanut butter. I wanted to capture more animated photos of her because her droopy jowls sometimes made her appear a little sad. More than a year later, I began photographing dogs in my studio eating peanut butter. I thought a photo series would be fun and keep me busy during my slow season in January and February. I posted a gallery of the photos online and, just like that, it went viral: selected photos were featured online and in newspapers around the world. Long story short, I signed a book deal and my first book, *Peanut Butter Dogs*, was released in 2017.

Nothing made me happier than to know people around the world were smiling and laughing because of my photos of dogs enjoying peanut butter. The ability to create something that brings joy to others is an unbelievably good feeling. While I thought I was set on only doing one book about dogs eating peanut butter, I was also eager to bring more joy, smiles, and laughter to the world. Three years later, in 2020, it only seemed fitting to make another peanut butter book.

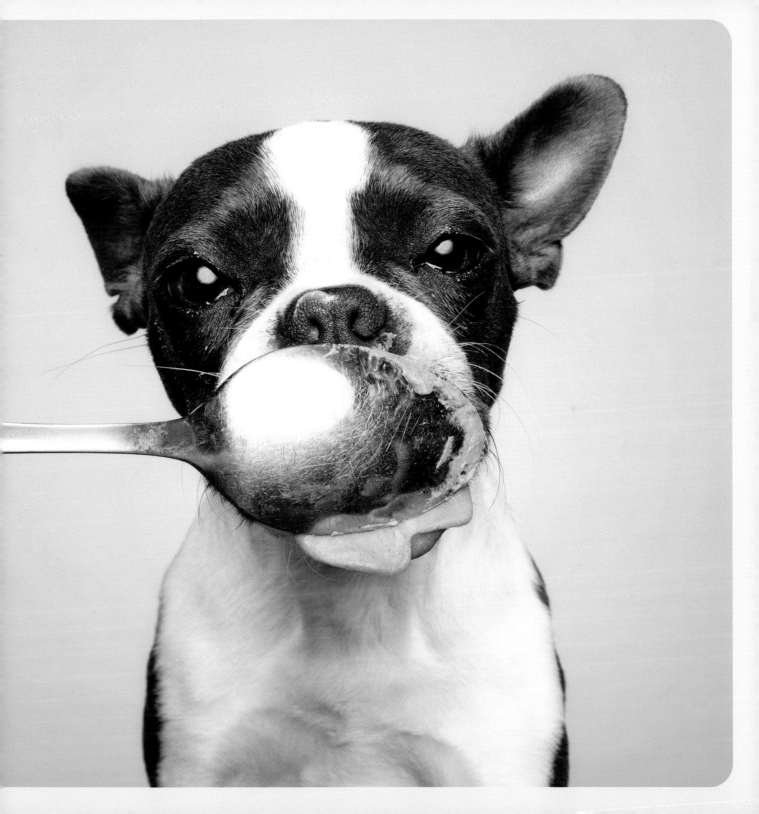

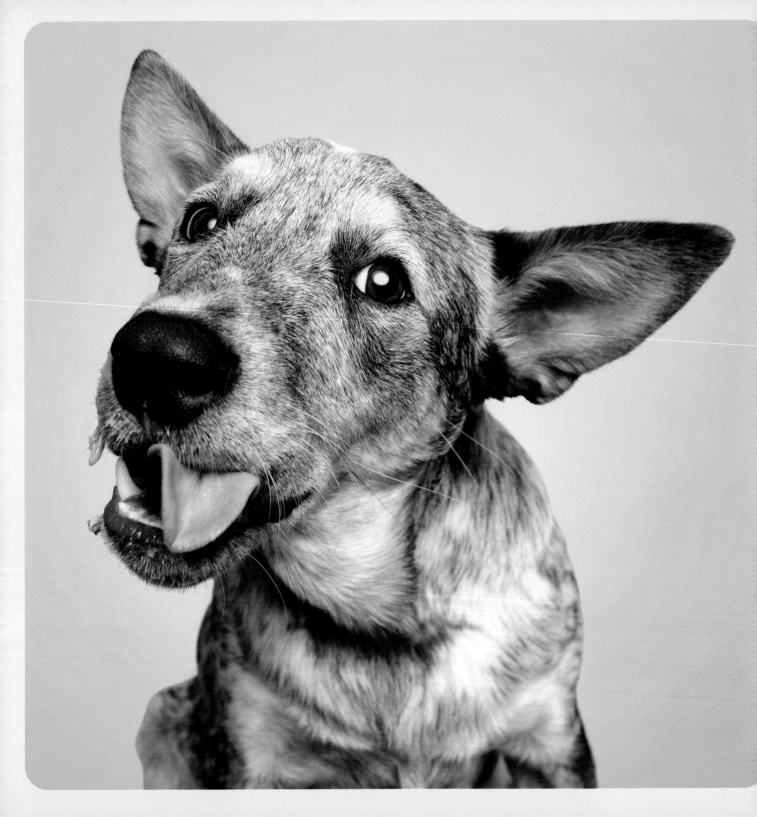

For the original *Peanut Butter Dogs* book, I photographed more than 140 dogs in about a three-month period. It was quite the whirlwind! While it was easy to find models (who wouldn't want their dog in a book?), it was difficult to photograph so many in a short period of time while simultaneously photographing animals for my regular pet-photography clients. When it came to *Peanut Butter Puppies*, I had more time and only had to photograph about seventy dogs. (Kind of sounds funny saying, "I *only* had to photograph about seventy dogs," and do it during a pandemic!) My goal for this book was to photograph a wide variety of mutts and breed-specific rescue puppies. About every three weeks, I posted a model call on my Facebook page, which provided me more than enough puppies to choose from. Some of the puppies were being fostered or were in the shelter when I photographed them and now are in loving forever homes. Some of these puppies were adopted during the pandemic to first-time dog owners looking for a furry companion to be part of their home. It was fun to work with first-time dog owners who were still navigating the world of puppyhood. I enjoyed offering advice, answering questions, and seeing their love for their new family member.

I chose to photograph only rescue dogs for *Peanut Butter Puppies* to help bring continued awareness to the importance of pet adoption. To save an animal's life is an amazing privilege. Beginning here, and moving forward, I have committed to only featuring rescue animals in any of my books. Millions of dogs and cats enter shelters and rescue organizations every year—puppies, kittens, aging seniors, and all ages in between. They need us, not only to adopt them but also to advocate, educate, volunteer, donate, sponsor, and foster on their behalf.

Together, let's continue to make a difference and decrease the number of homeless animals. If you haven't done so already, please consider saving a life next time you are ready to welcome a pet into your home. You will not regret it.

—*GREG MURRAY*

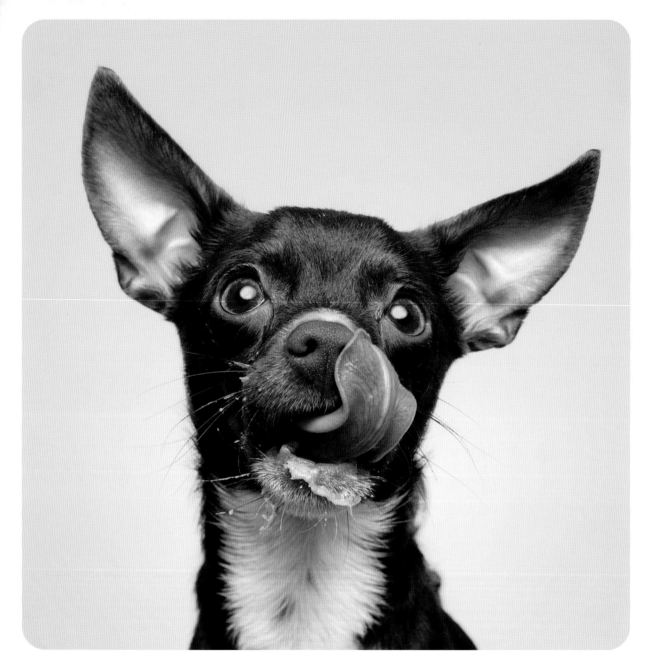

ARCHIE
7 months
Chihuahua

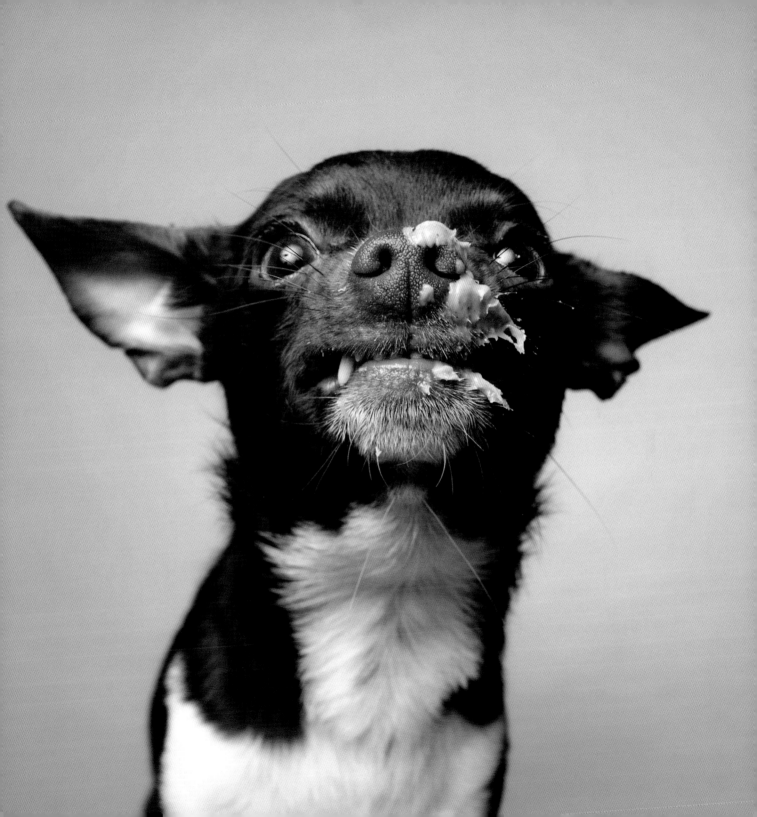

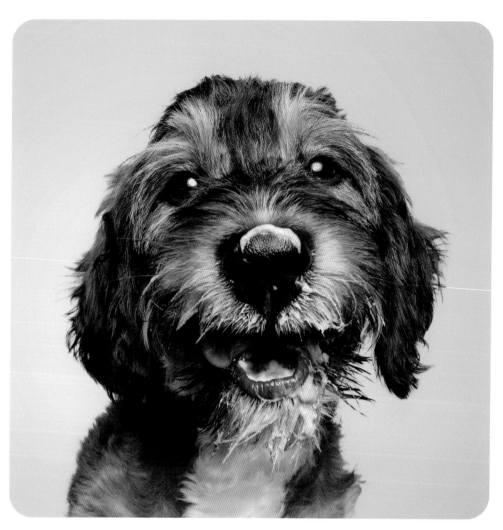

AURORA
6 months
Bernese mountain dog/poodle mix

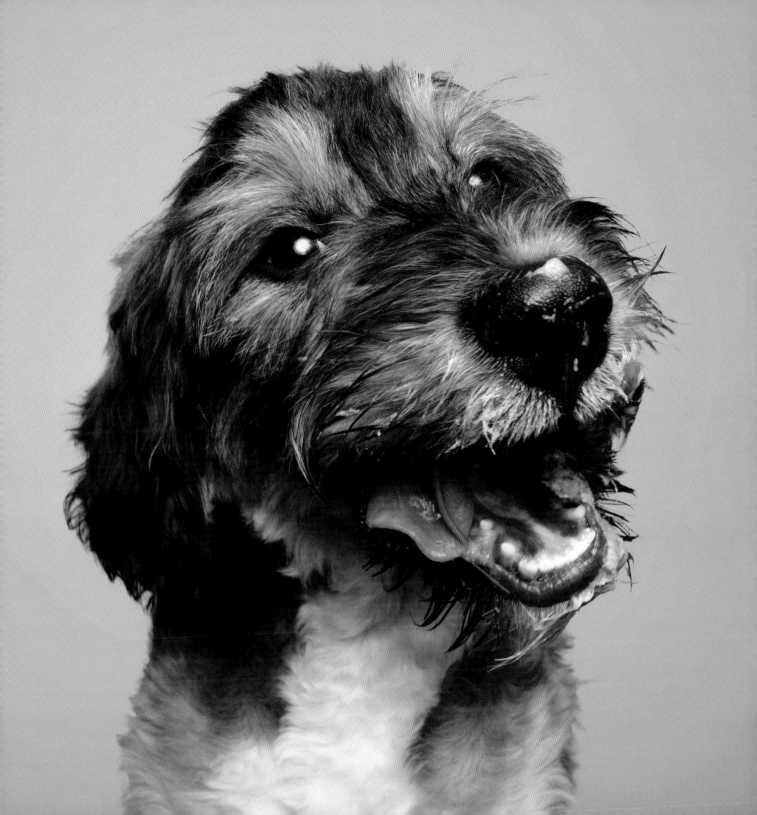

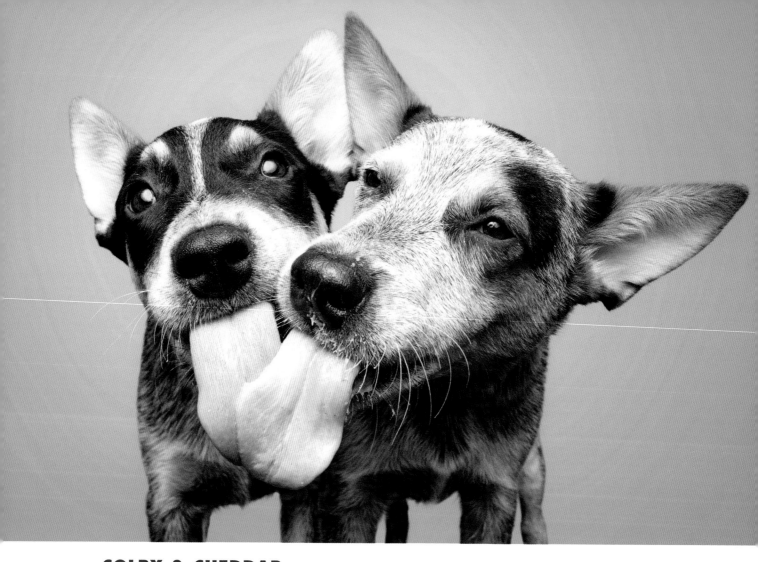

COLBY & CHEDDAR
5 months
Australian cattle dogs

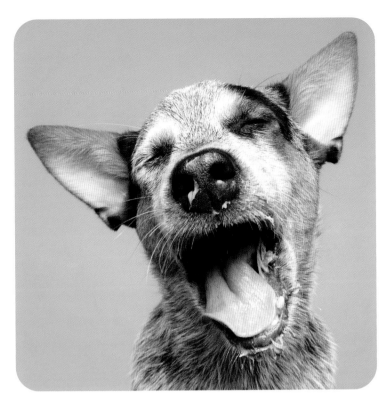

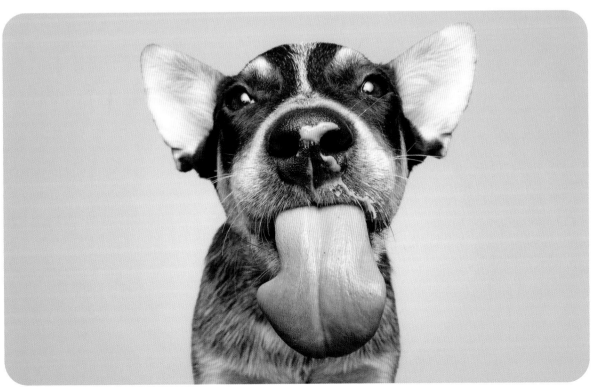

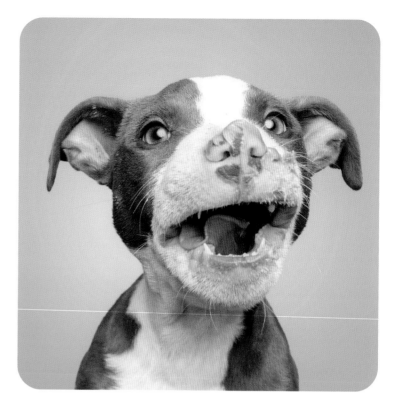

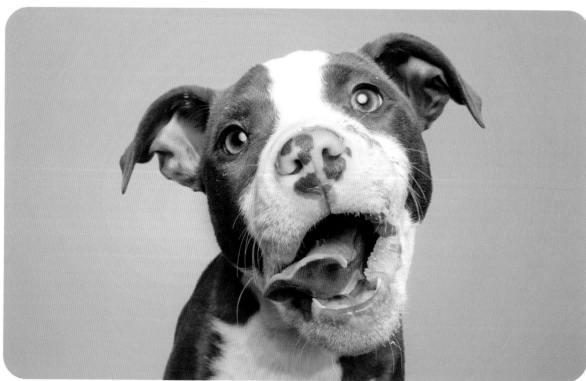

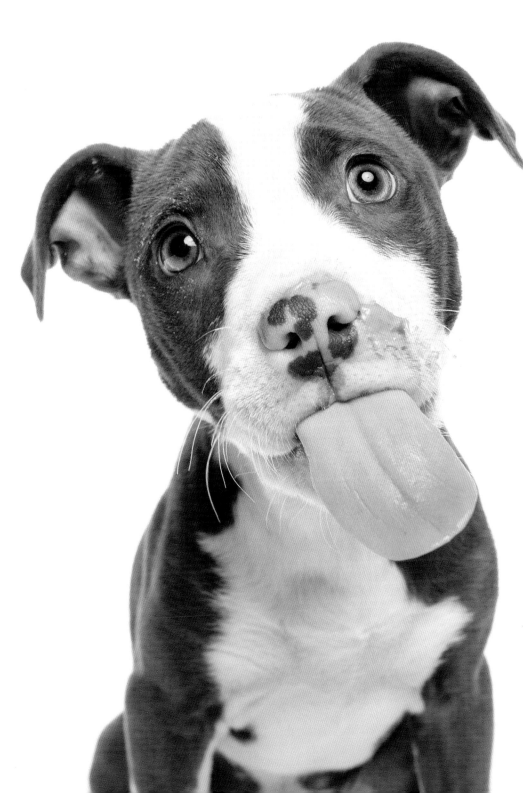

ZOLA
8 weeks
Pit bull mix

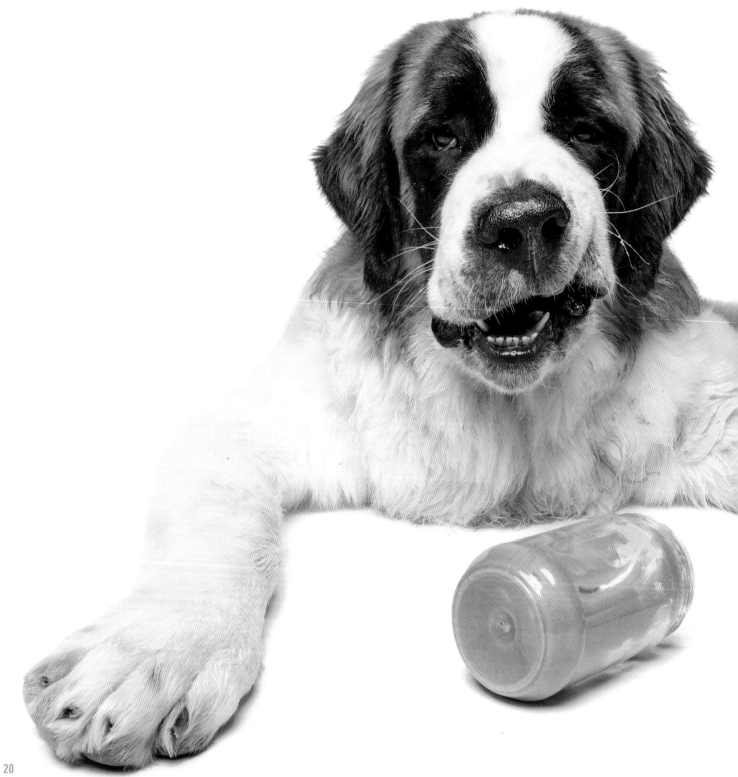

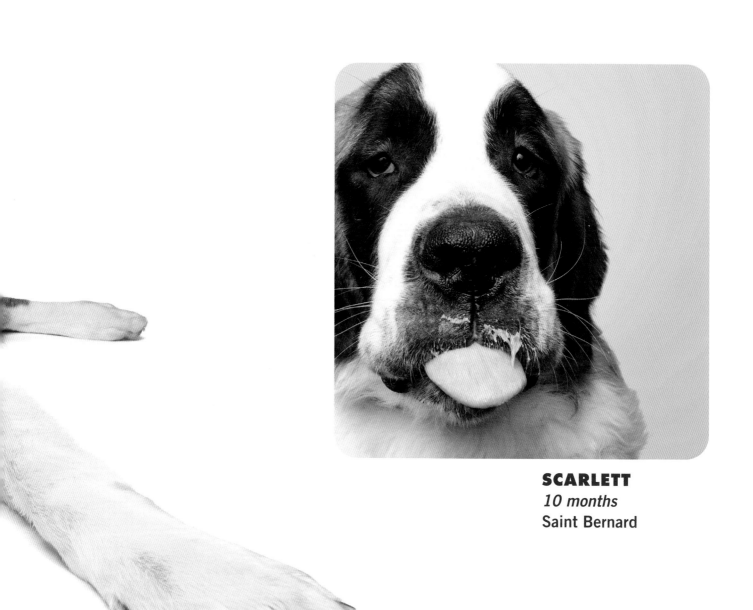

SCARLETT
10 months
Saint Bernard

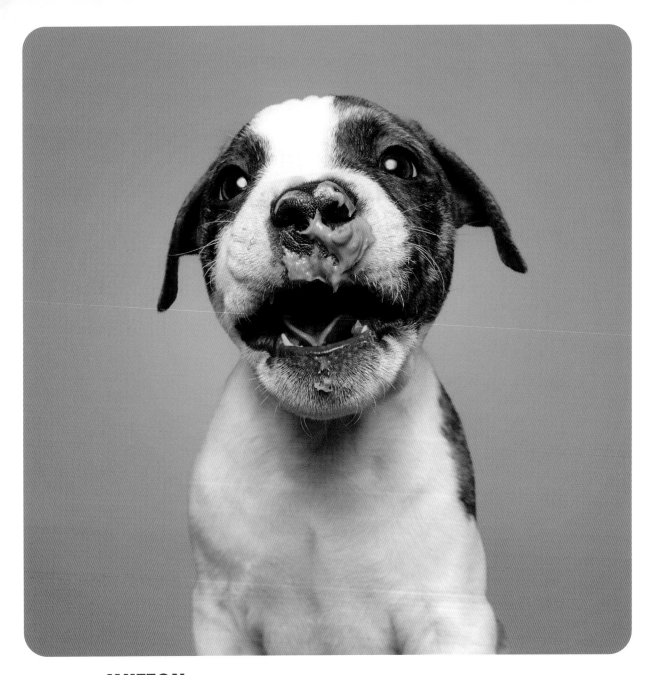

MUTTON
9 weeks
Pit bull mix

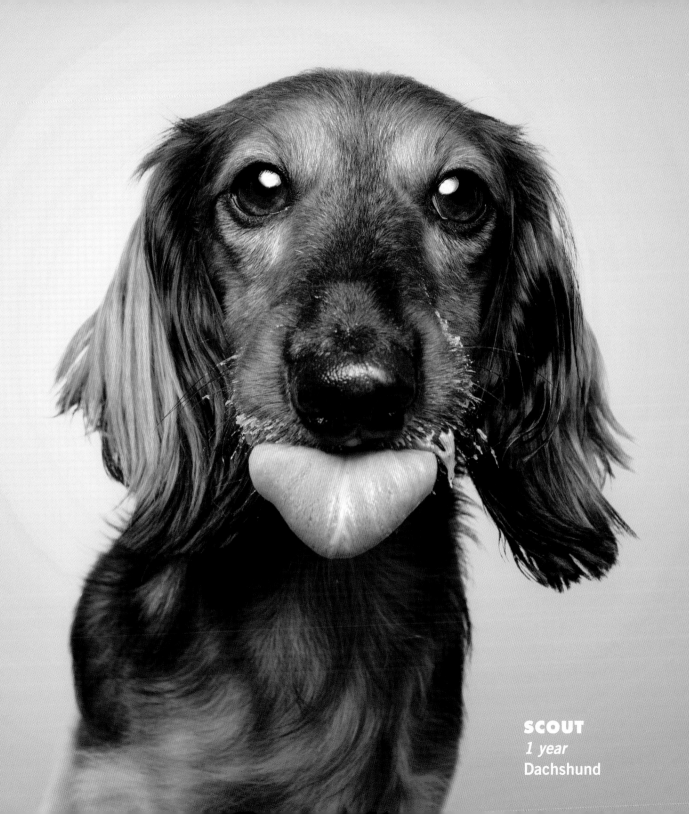

SCOUT
1 year
Dachshund

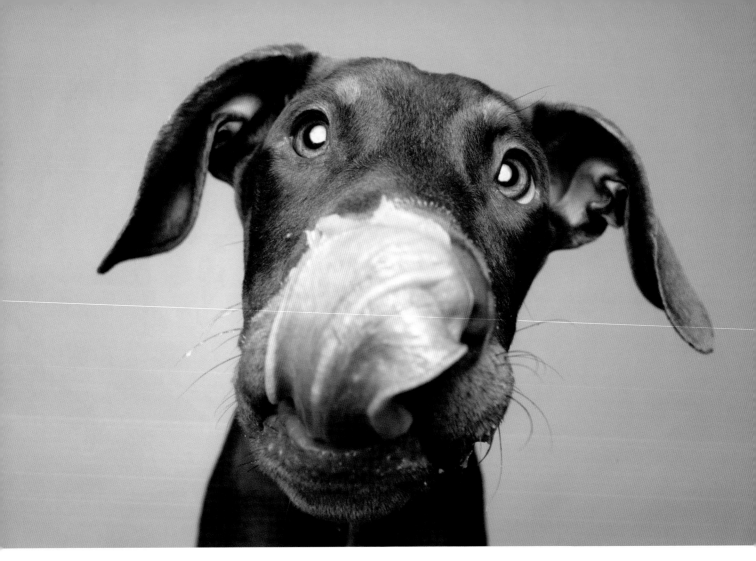

ARLO
4 months
Doberman pinscher

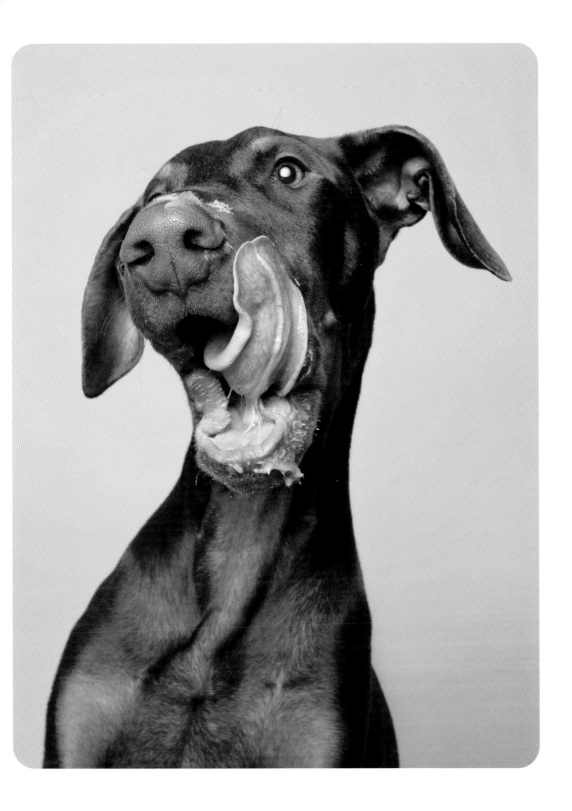

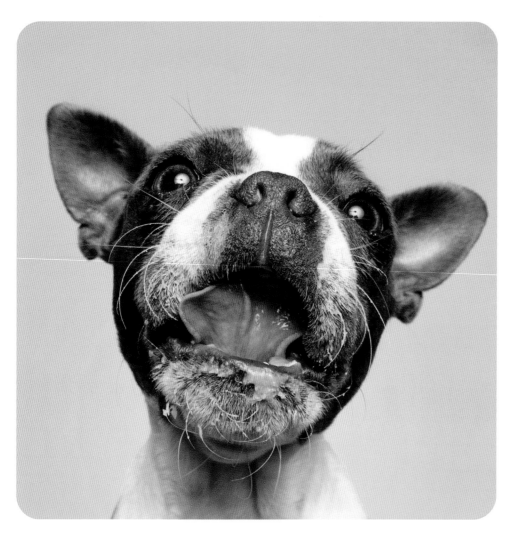

FIONA WIGGLESWORTH
8 months
Boston terrier

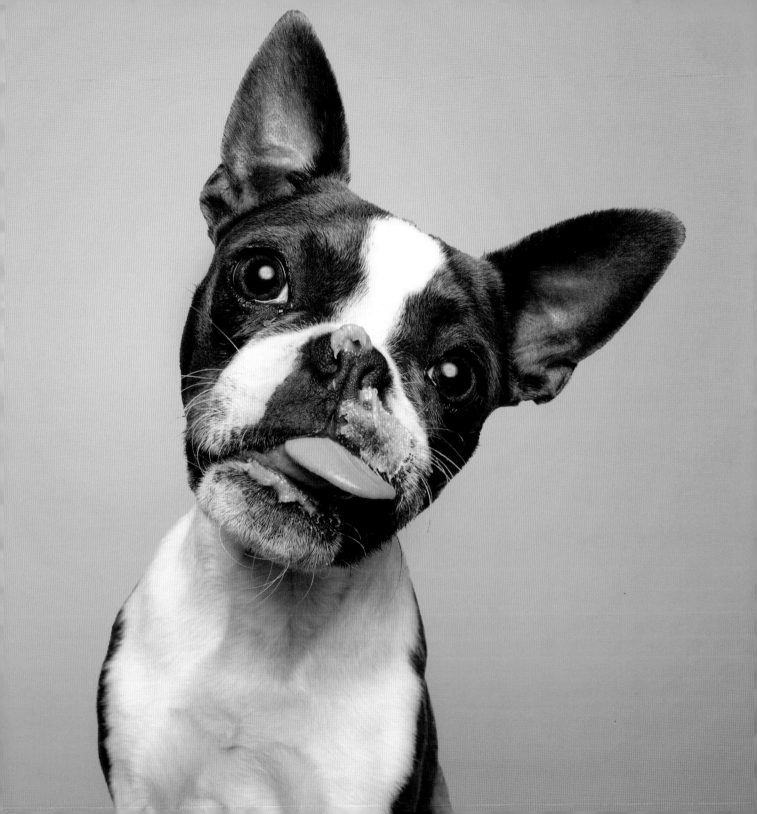

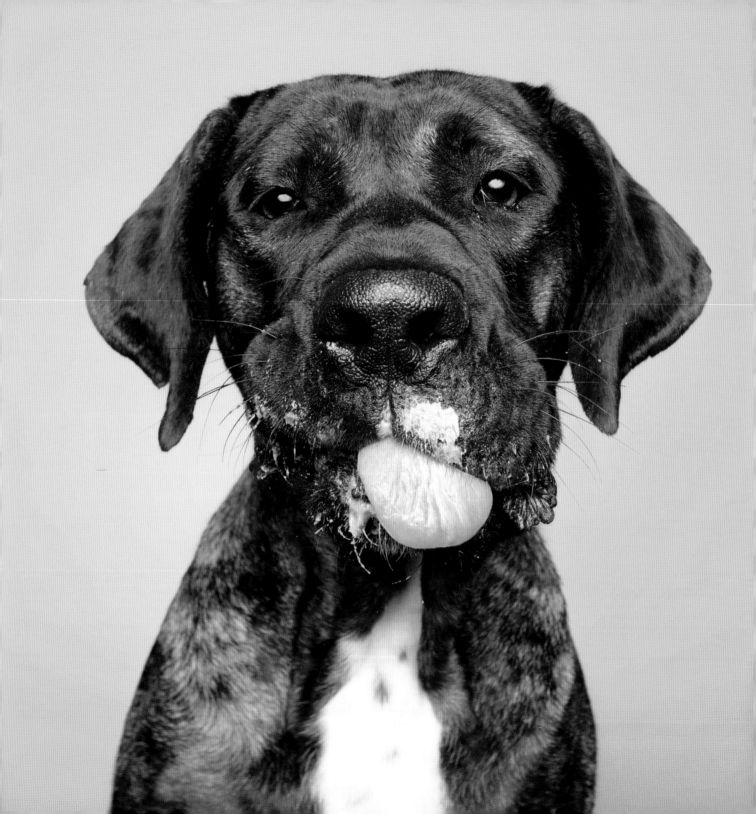

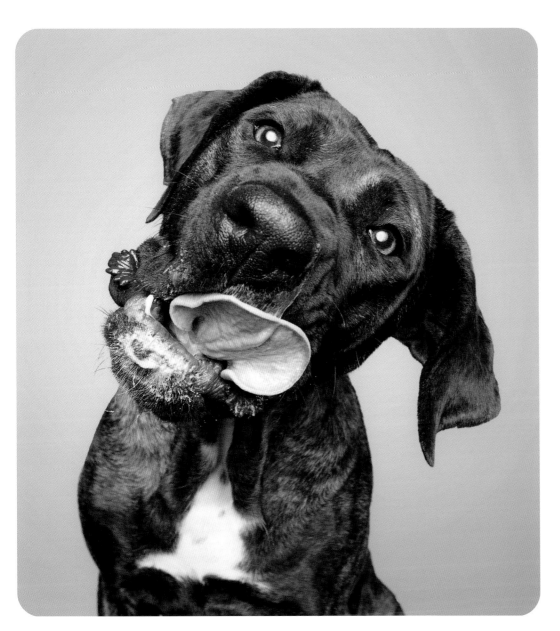

ZOEY
9 months
Mastiff mix

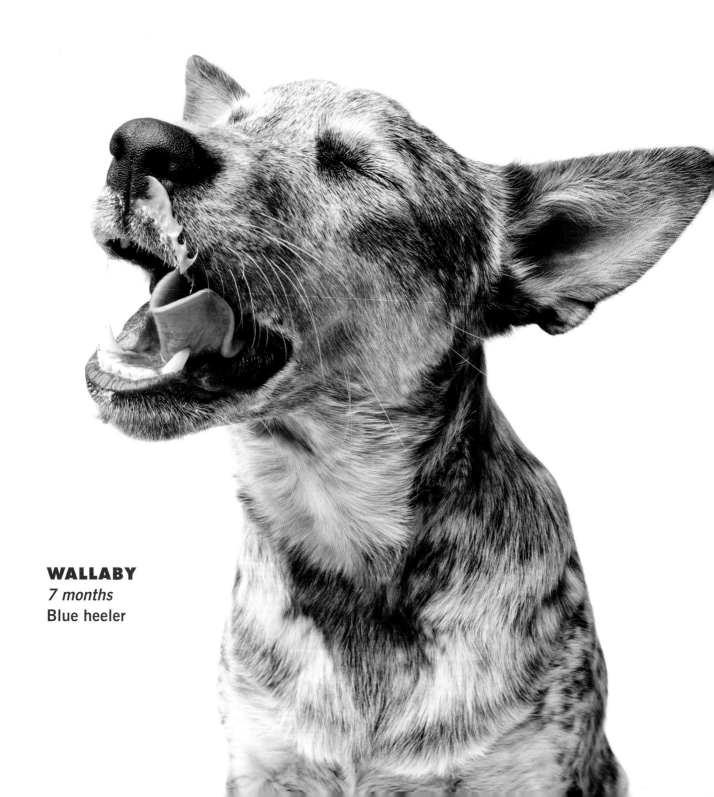

WALLABY
7 months
Blue heeler

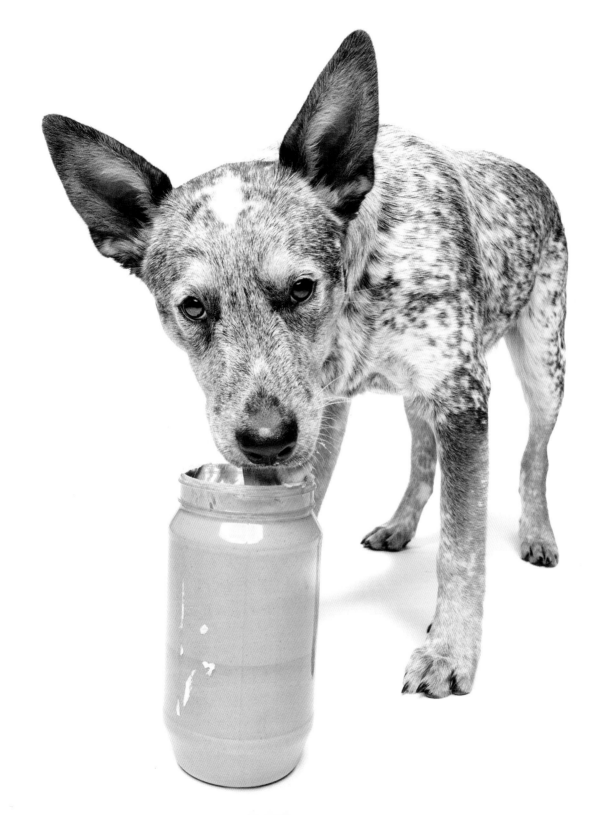

31

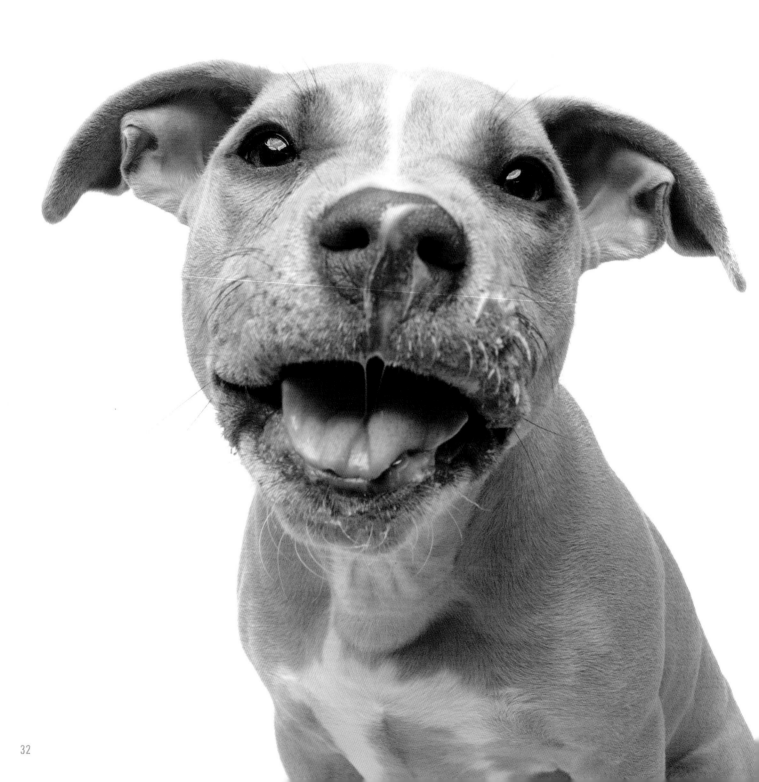

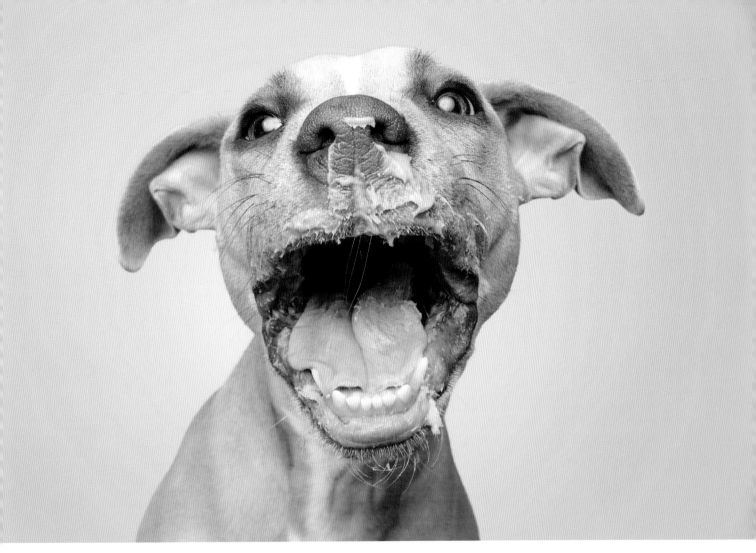

CALI
5 months
Pit bull mix

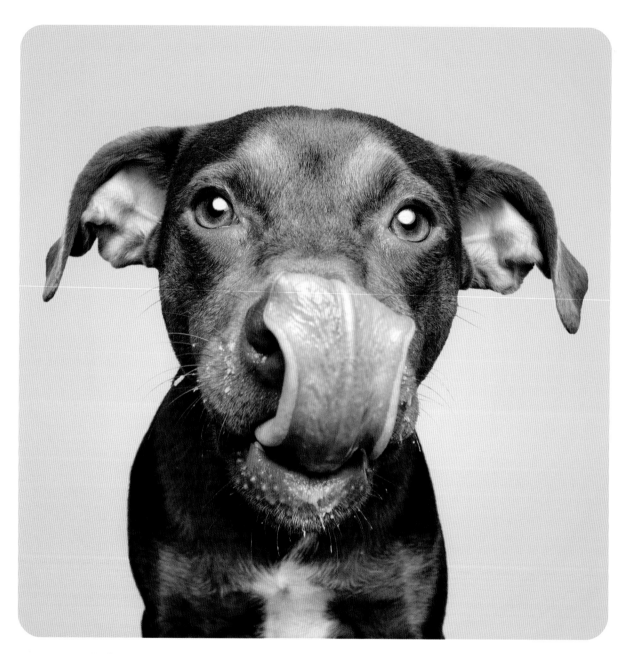

TORI
8 months
Doberman mix

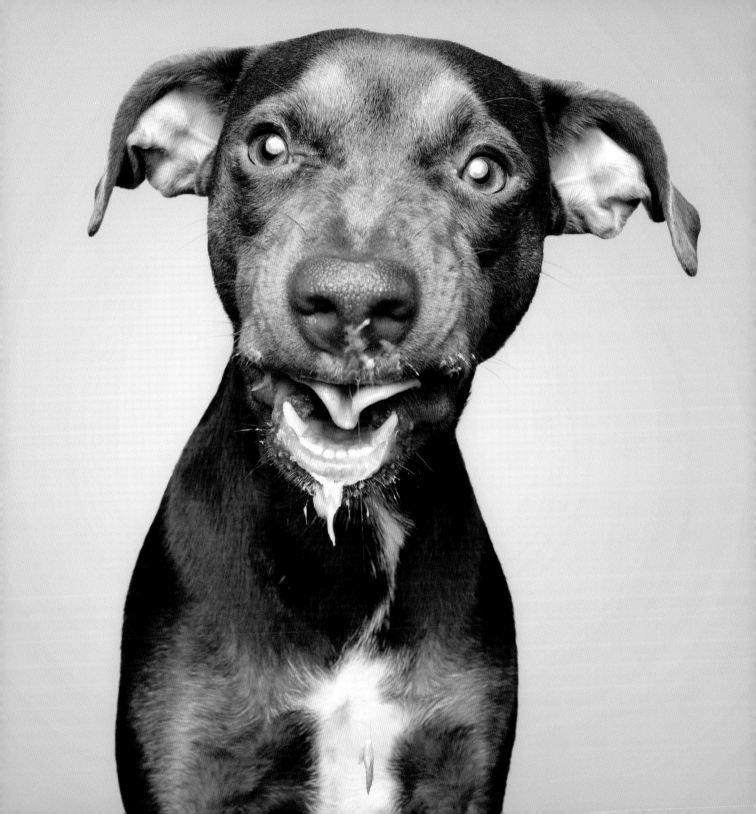

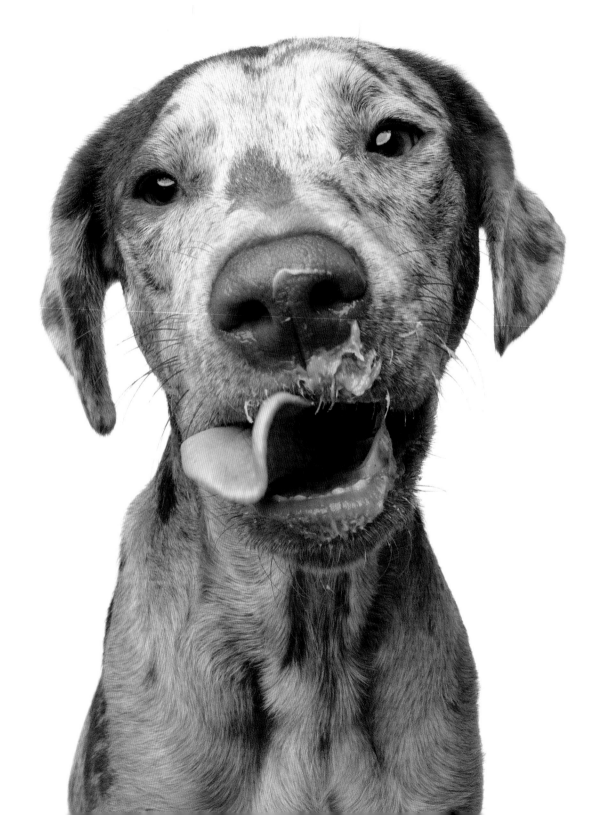

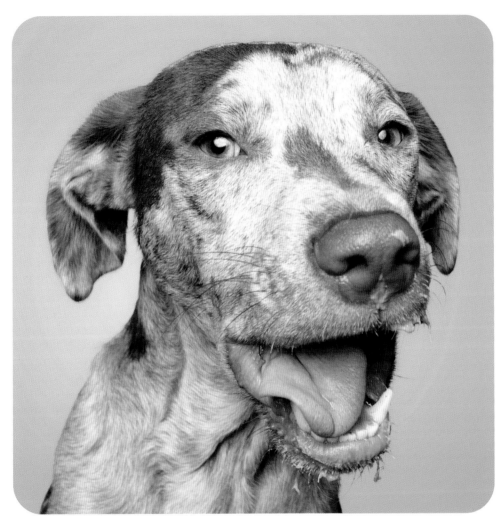

BODHI
11 months
Catahoula/pit bull mix

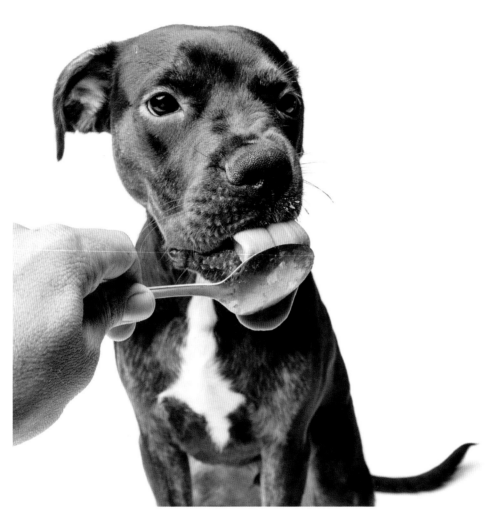

BEAN
7 months
Labrador retriever/boxer mix

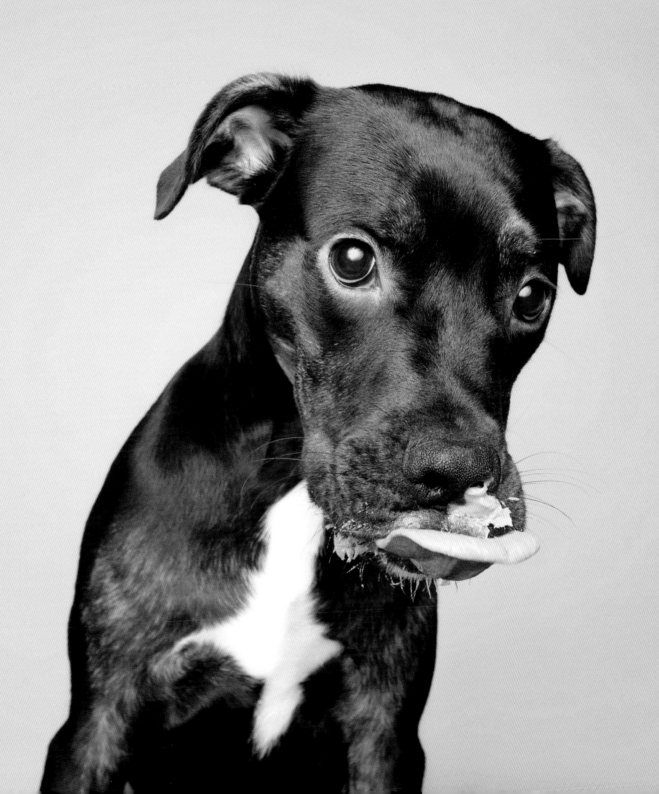

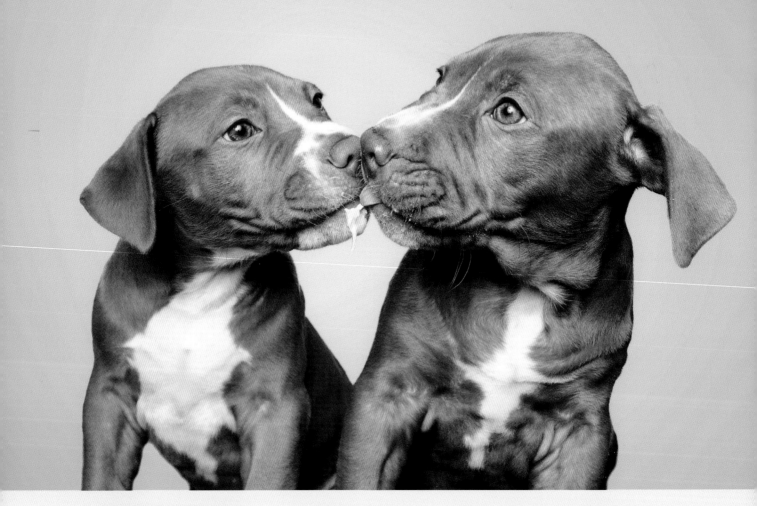

YOGI & TULLY
10 weeks
Pit bull mixes

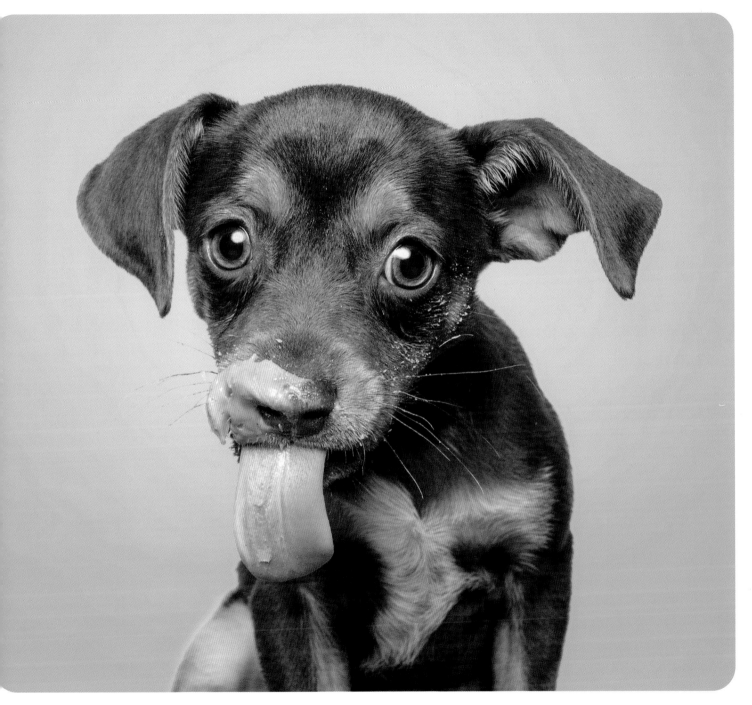

GINNIE
10 weeks
Chihuahua mix

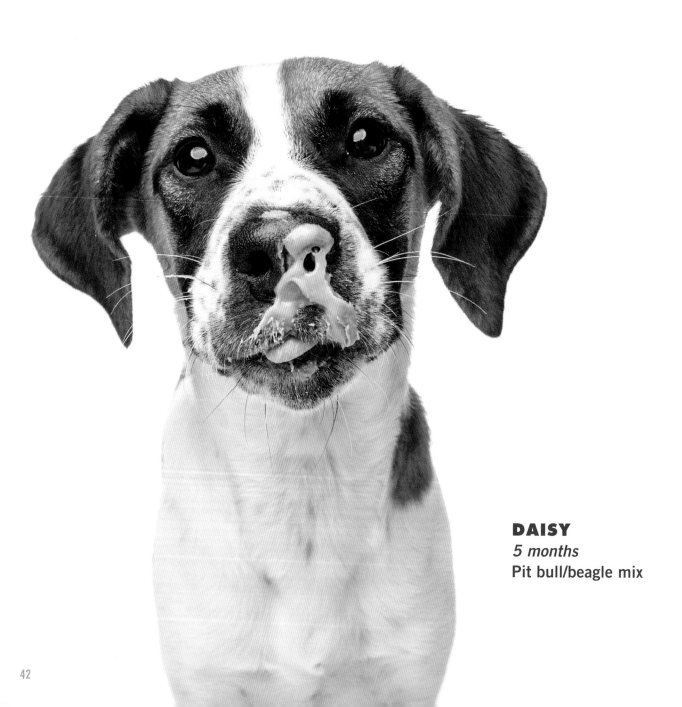

DAISY
5 months
Pit bull/beagle mix

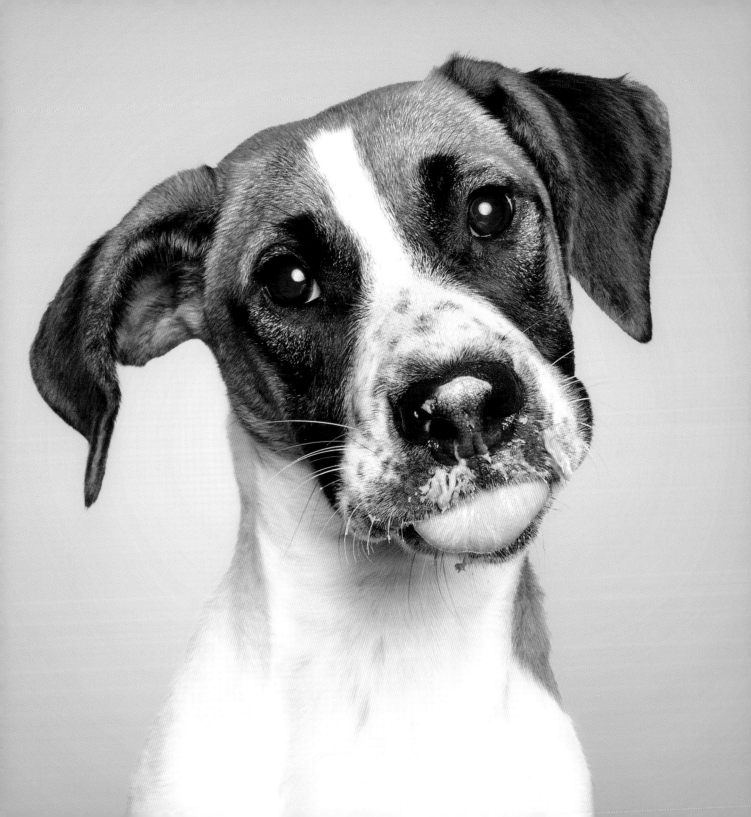

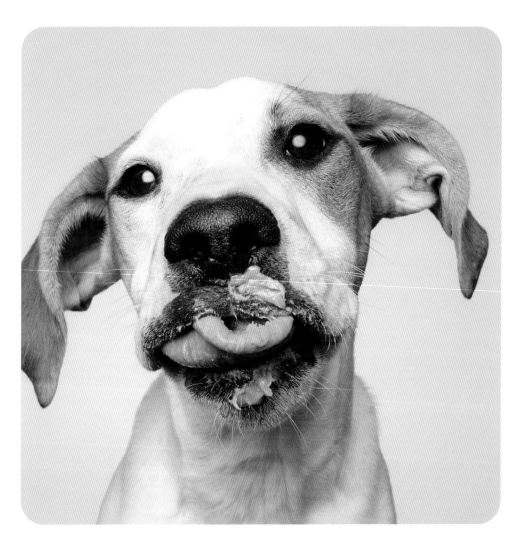

DODGER
5 months
Pit bull/beagle mix

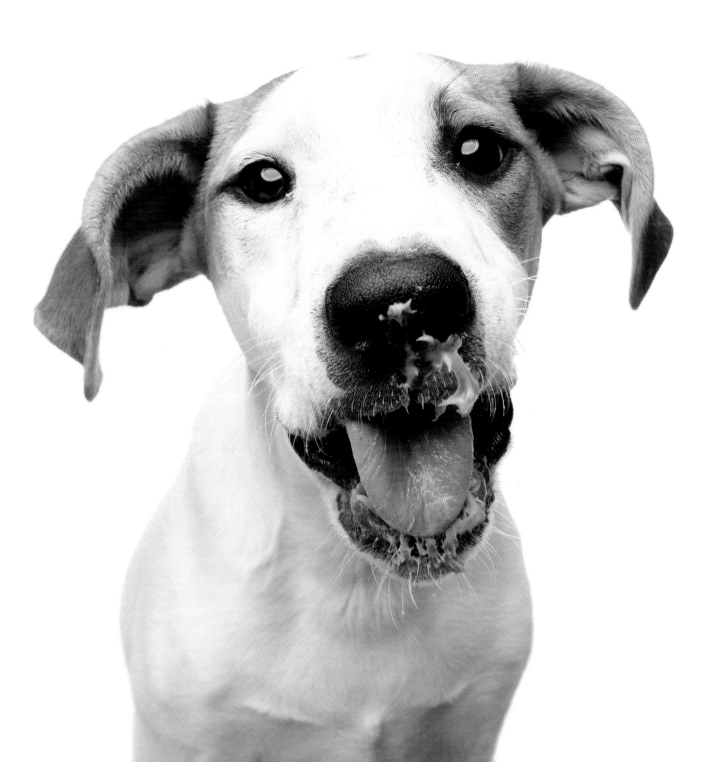

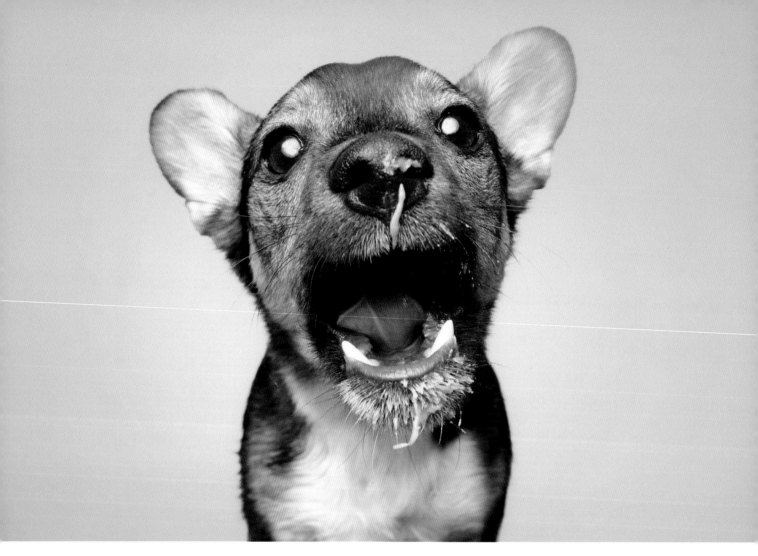

REED
6 months
Corgi/terrier/miniature pinscher mix

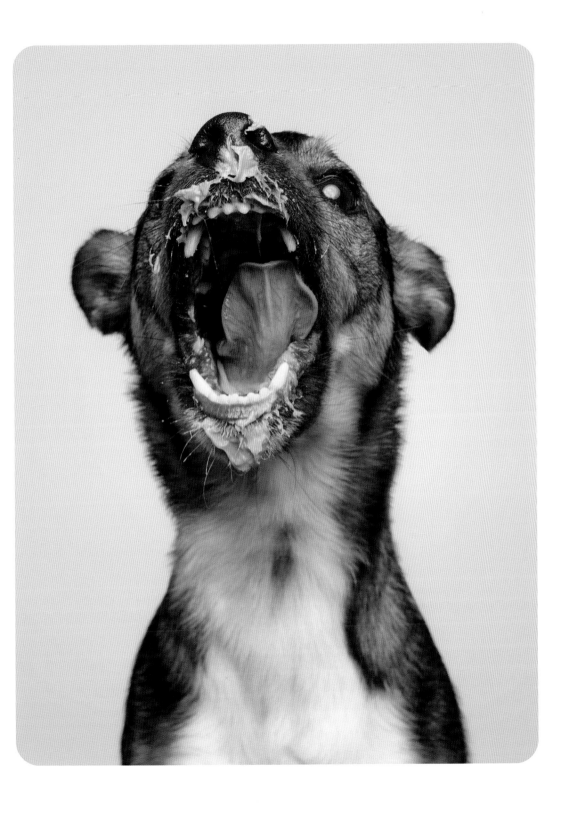

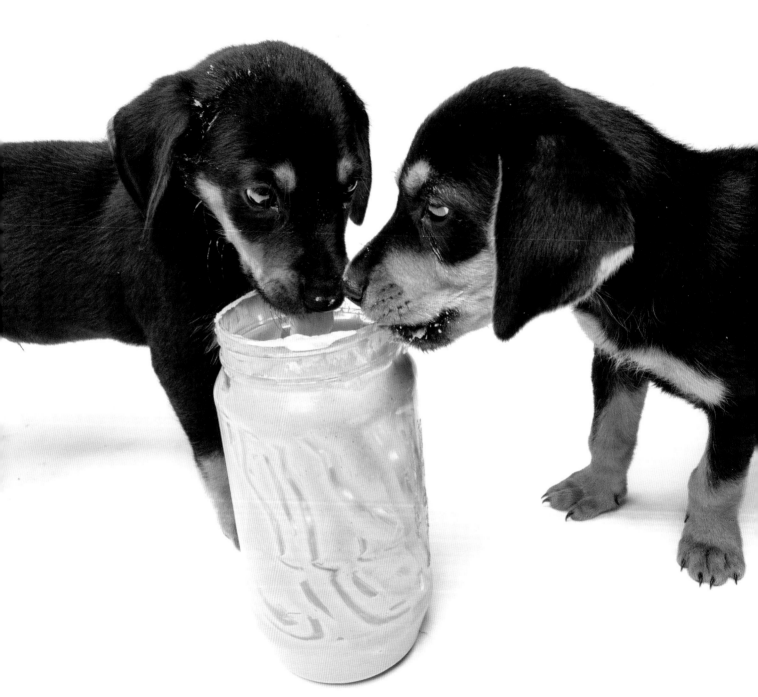

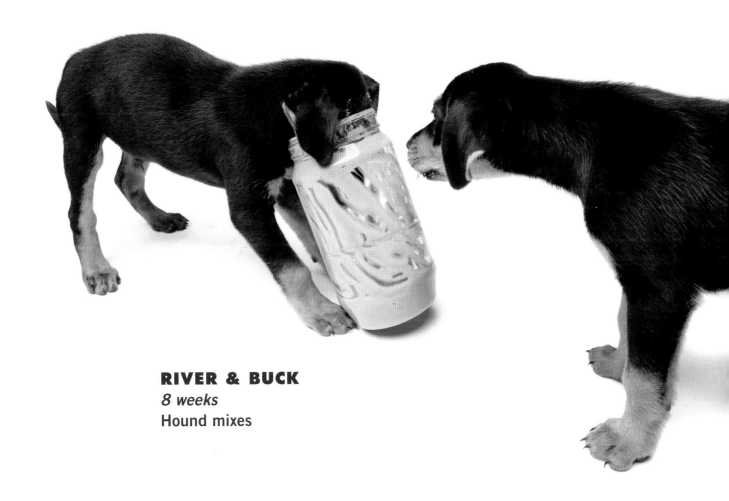

RIVER & BUCK
8 weeks
Hound mixes

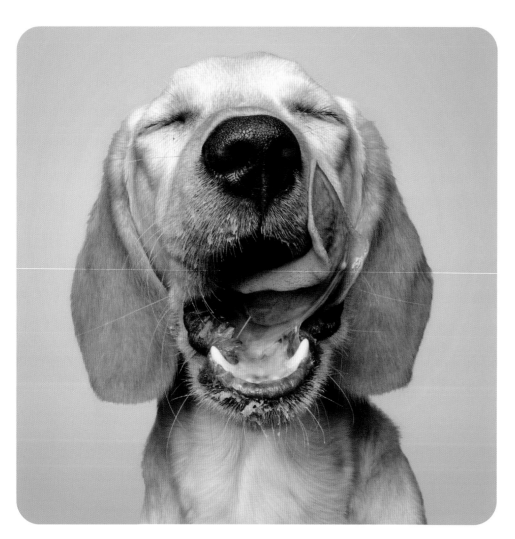

DOLLY
7 months
Beagle mix

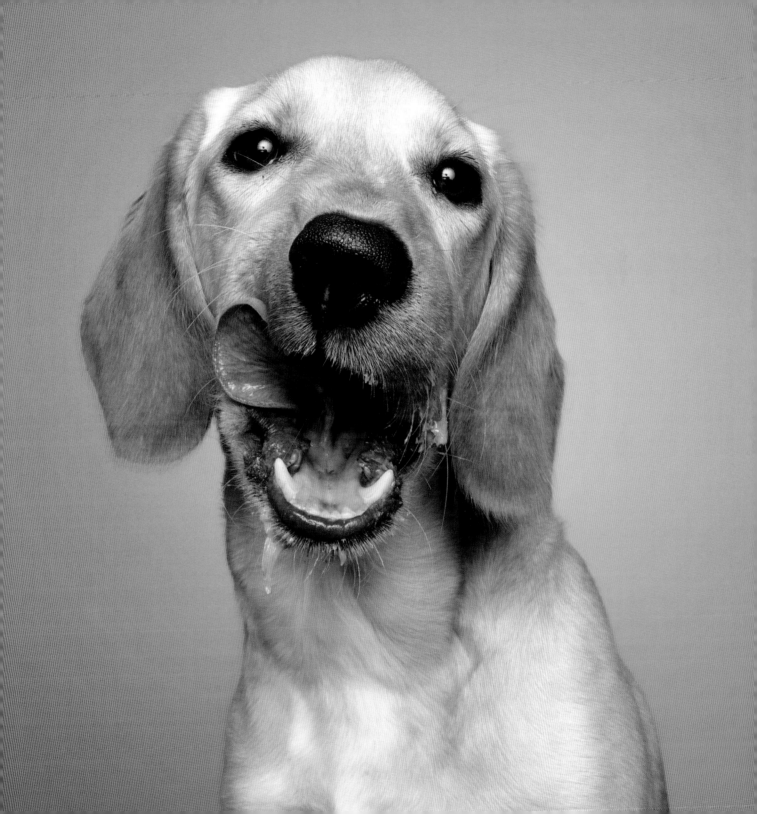

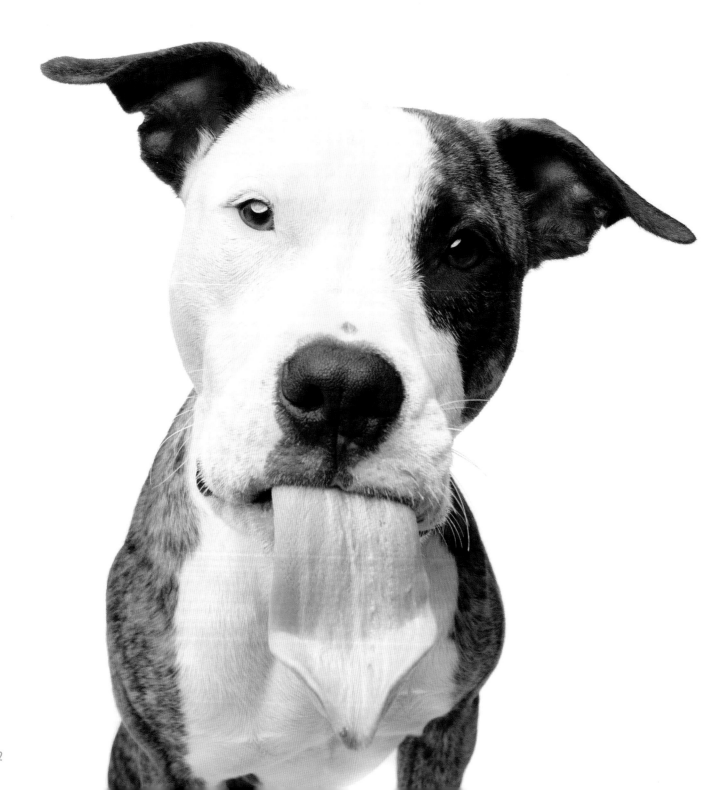

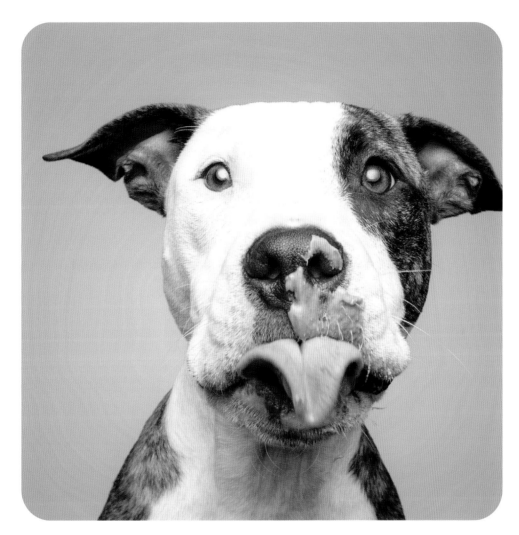

CROWLER
7 months
Pit bull mix

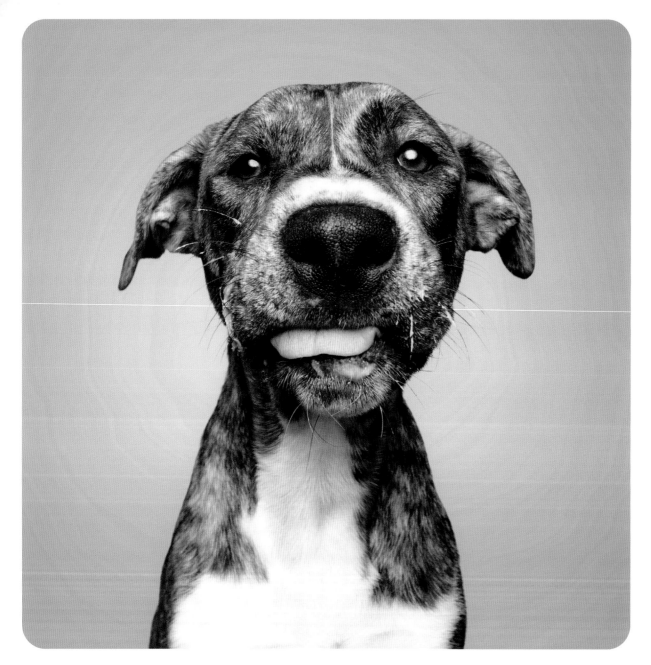

RUFUS
5 months
Great Dane mix

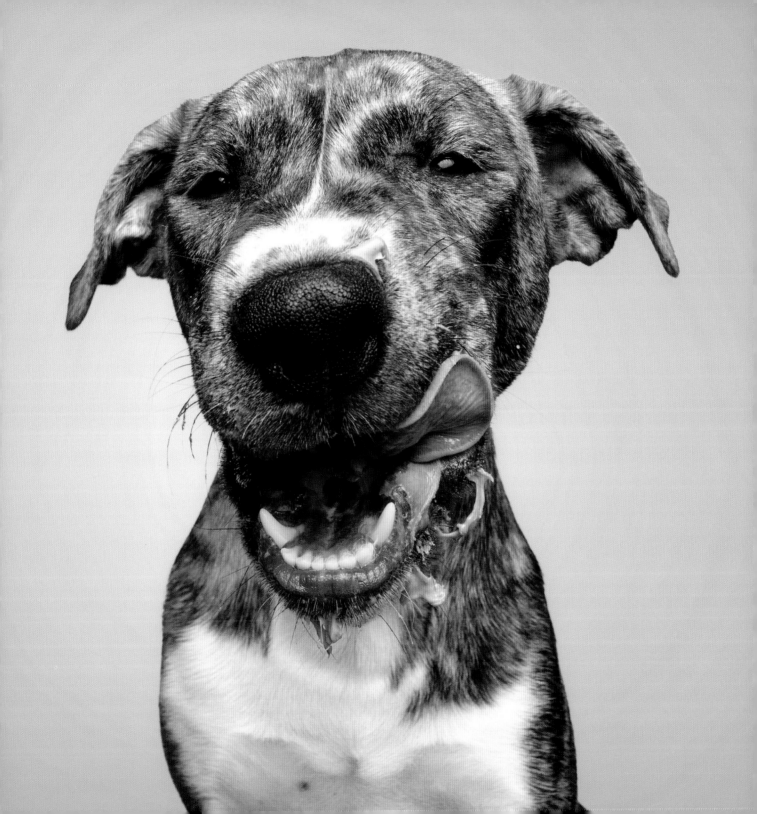

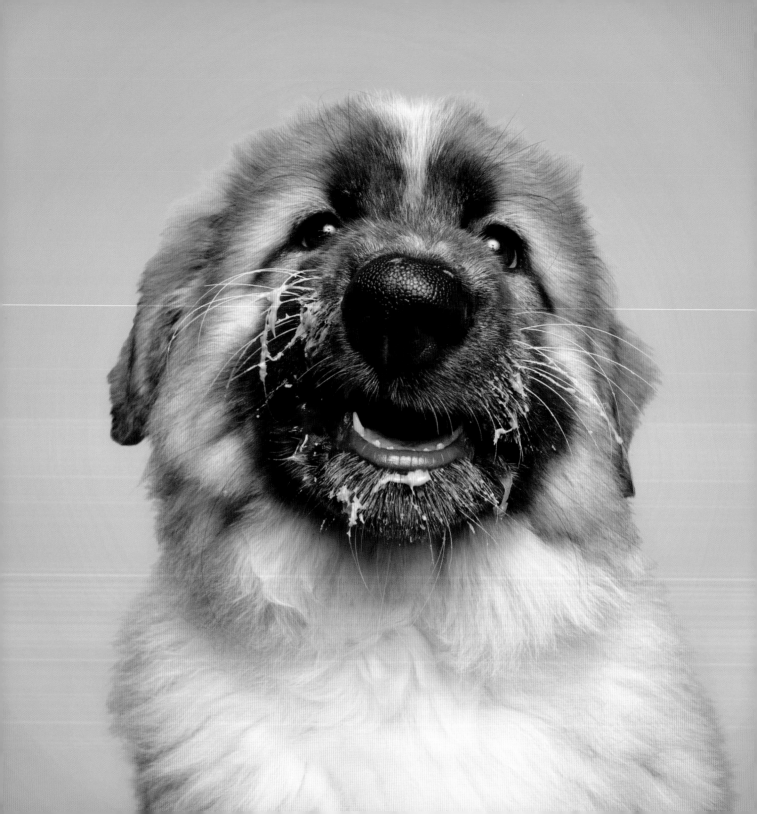

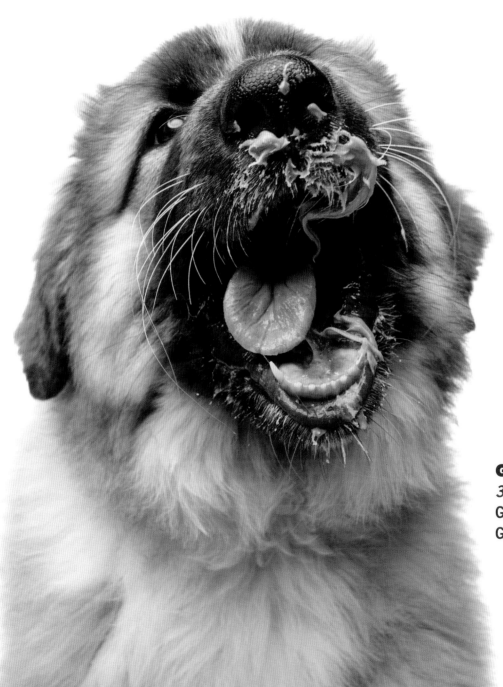

GRETA
3 months
Great Pyrenees/
German shepherd mix

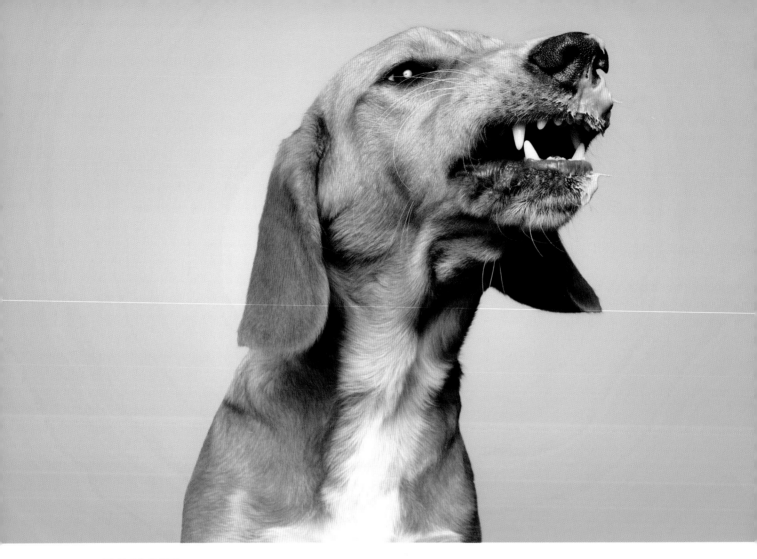

RANGER
8 months
Beagle mix

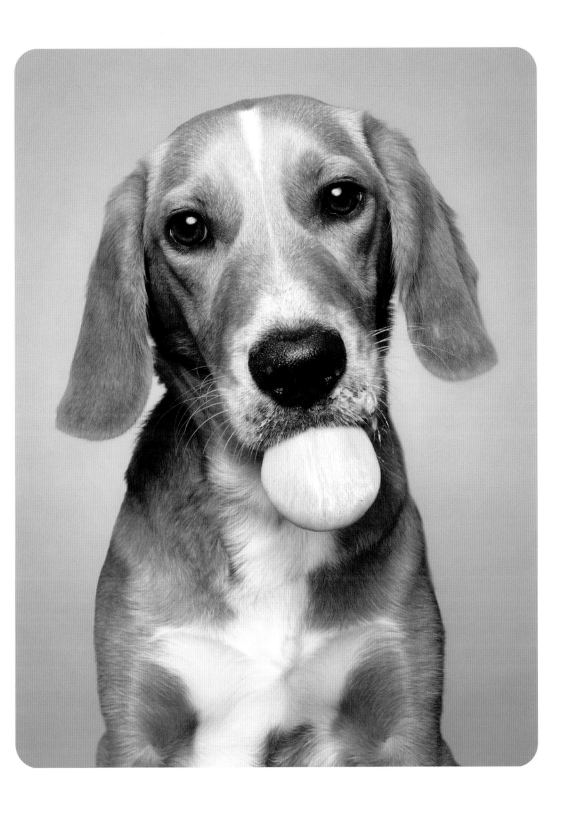

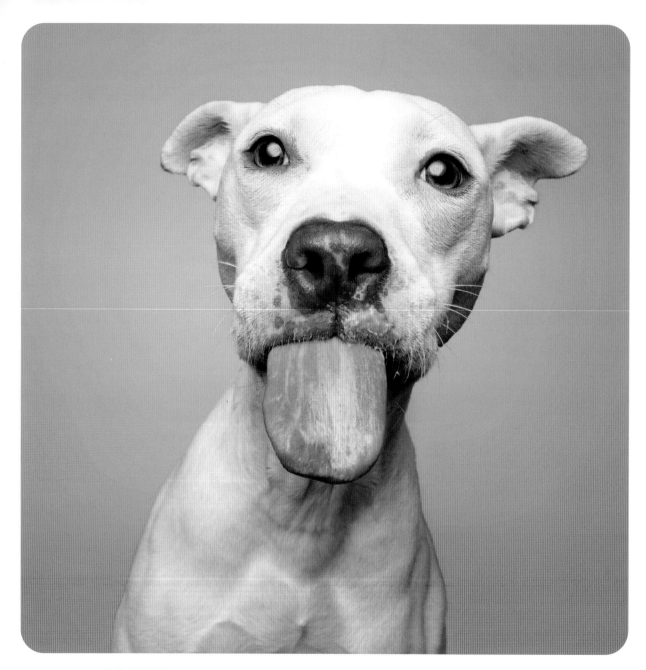

SOPHIE
10 months
Pit bull mix

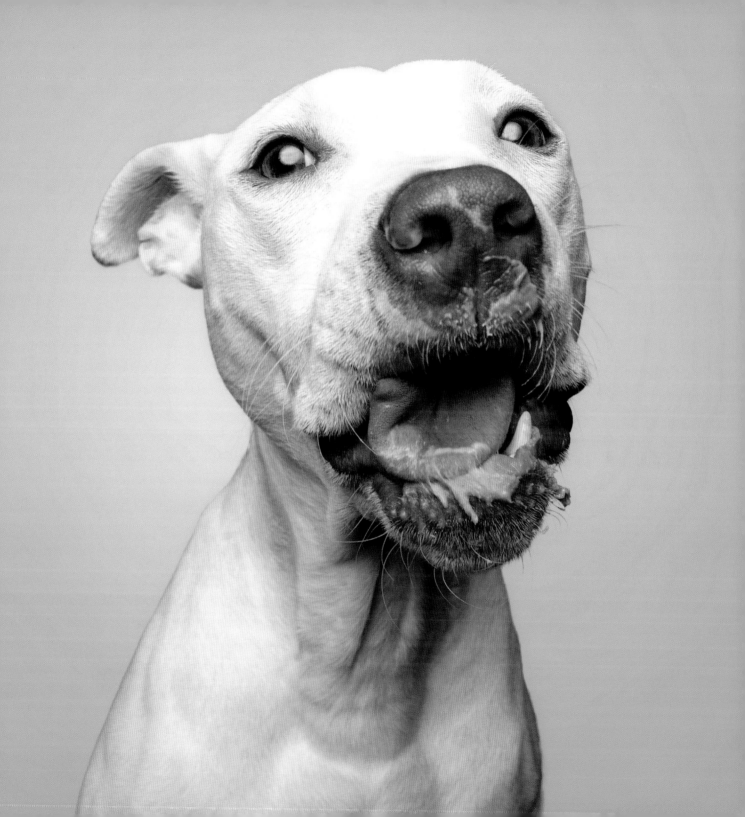

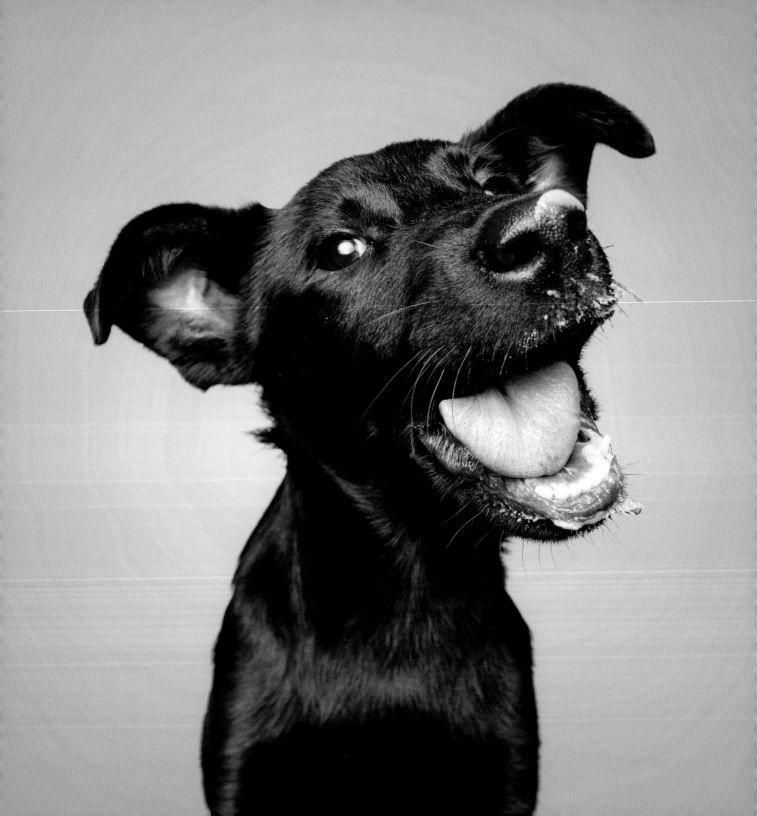

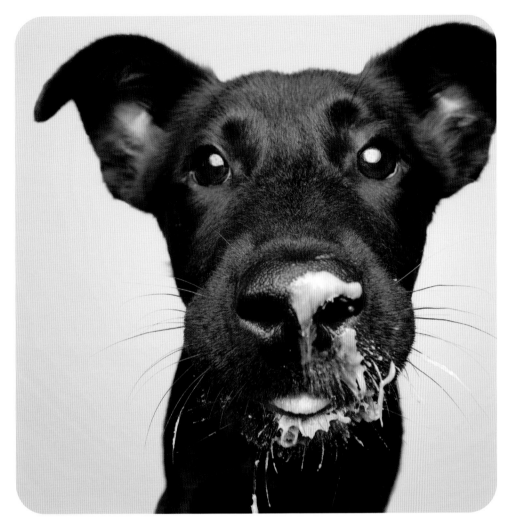

BUGG
5 months
Shepherd/retriever mix

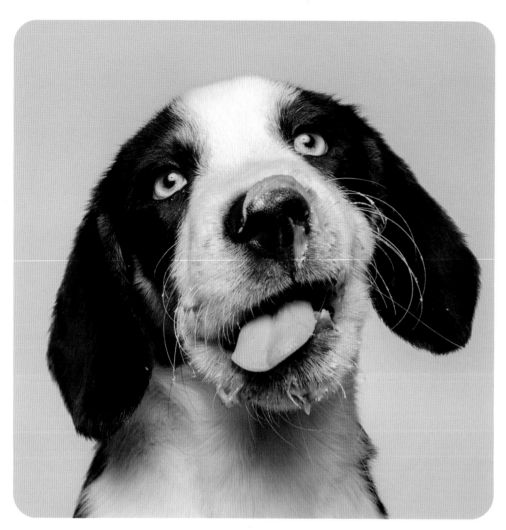

HOWIE
10 weeks
Beagle/border collie mix

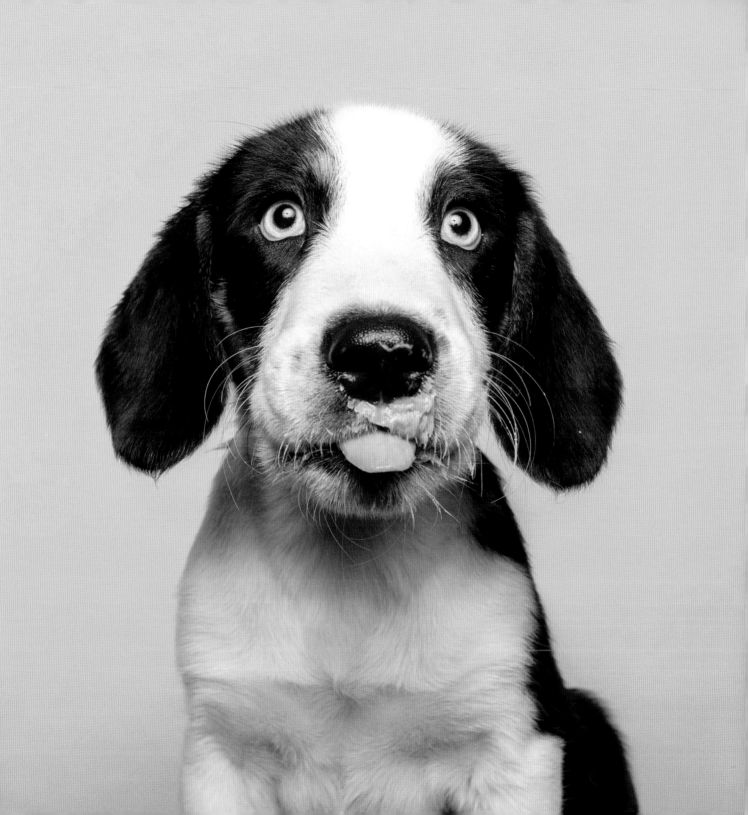

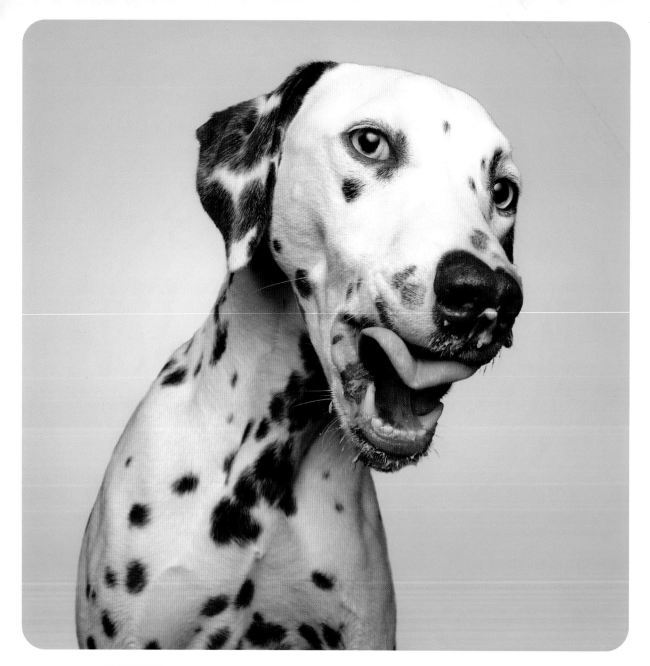

QUINT
1 year
Dalmatian

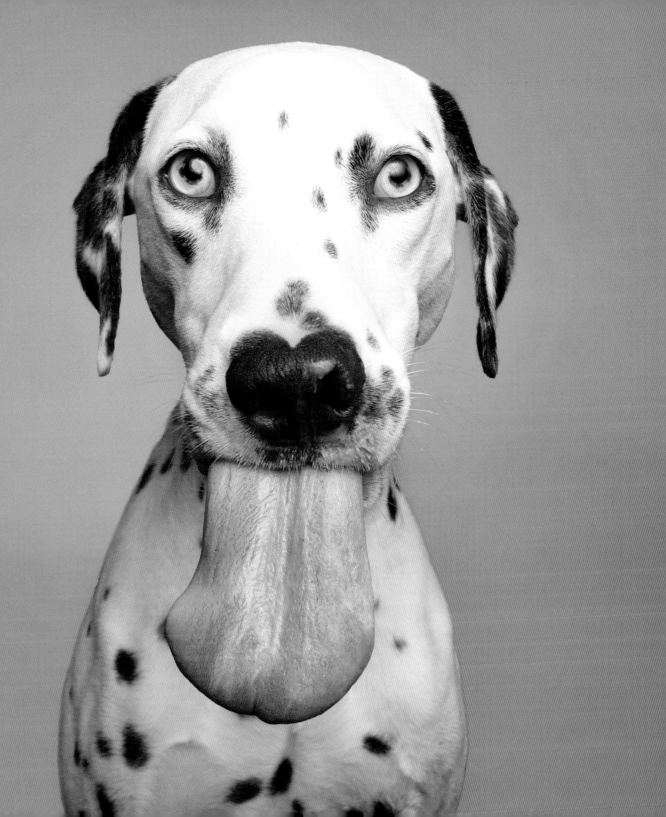

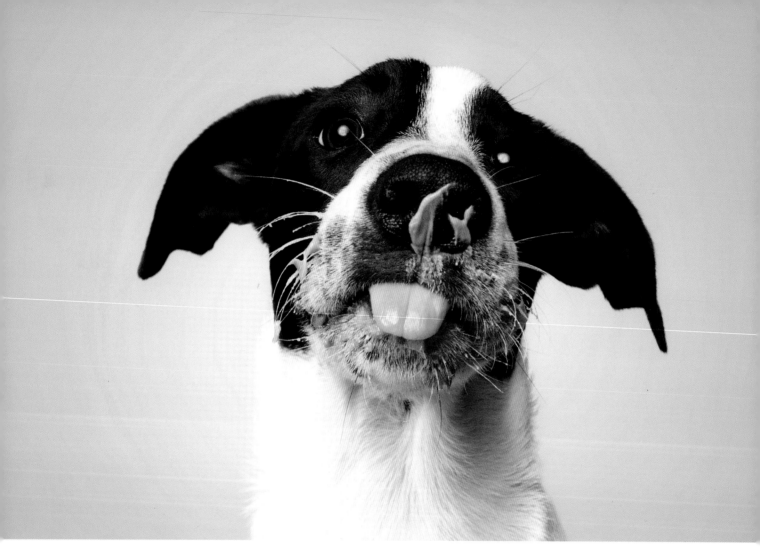

ZIA
6 months
Great Pyrenees mix

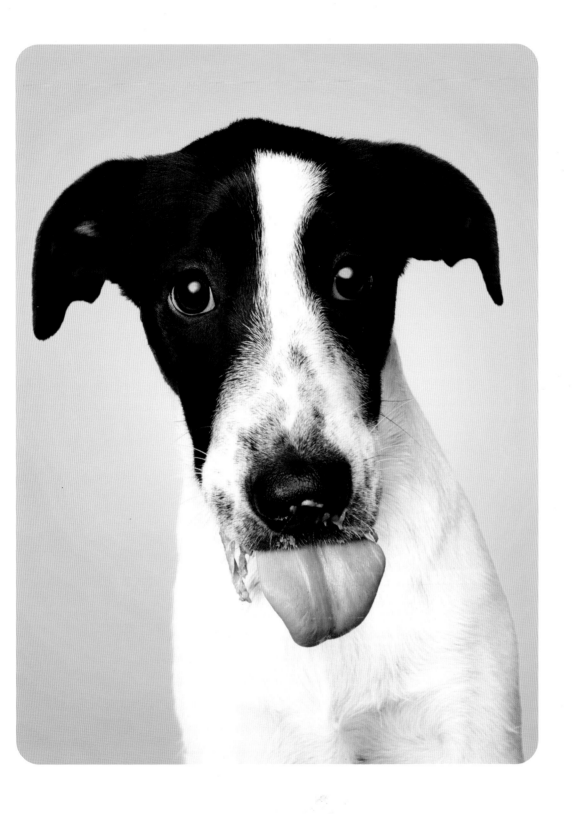

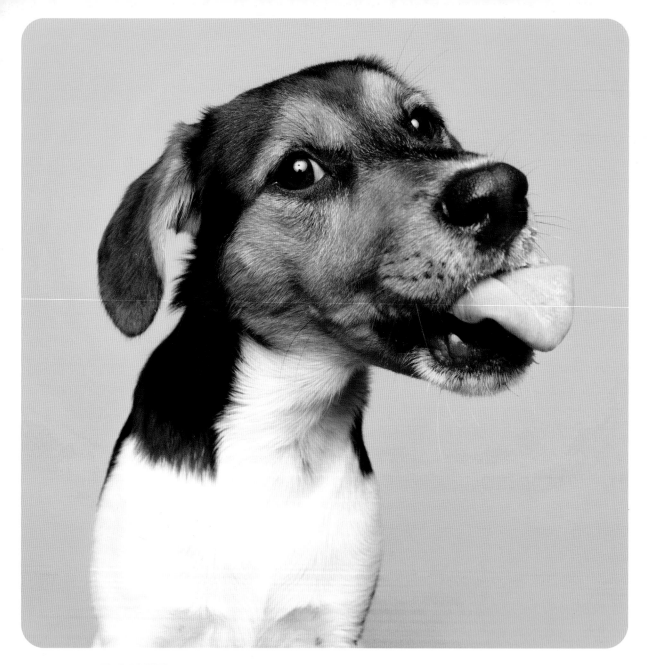

BAILEY
5 months
Pit bull mix

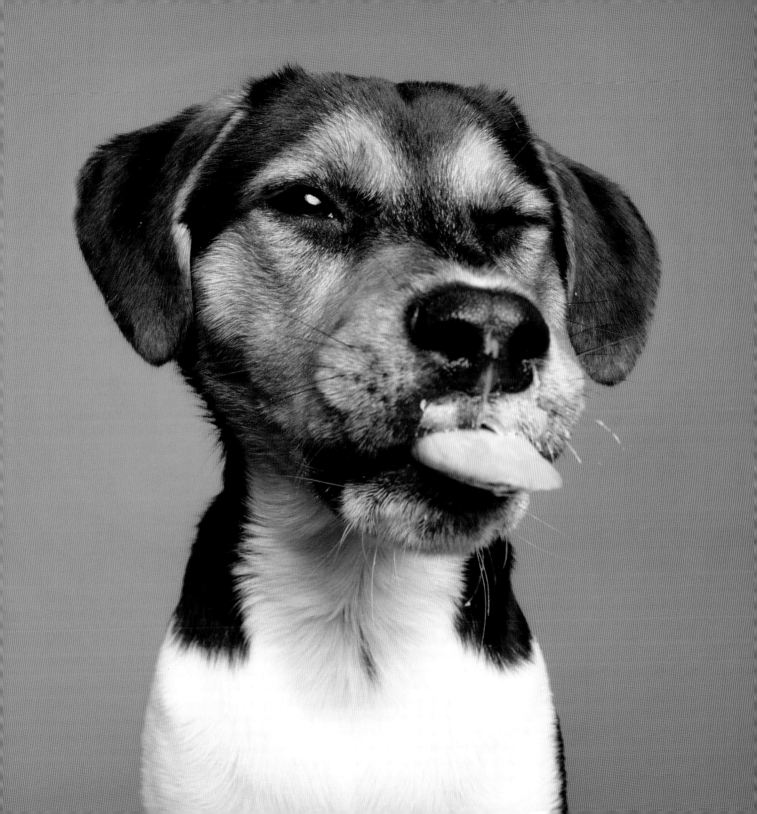

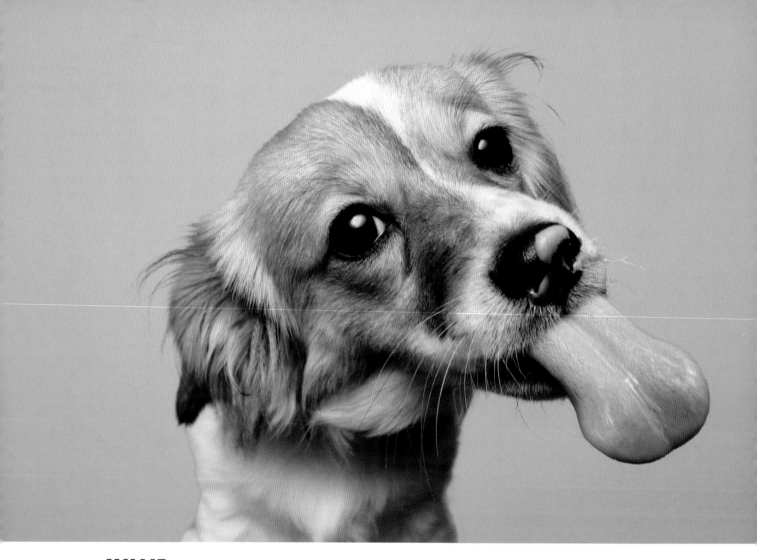

MILLIE
6 months
Cocker spaniel/
Chihuahua/pug mix

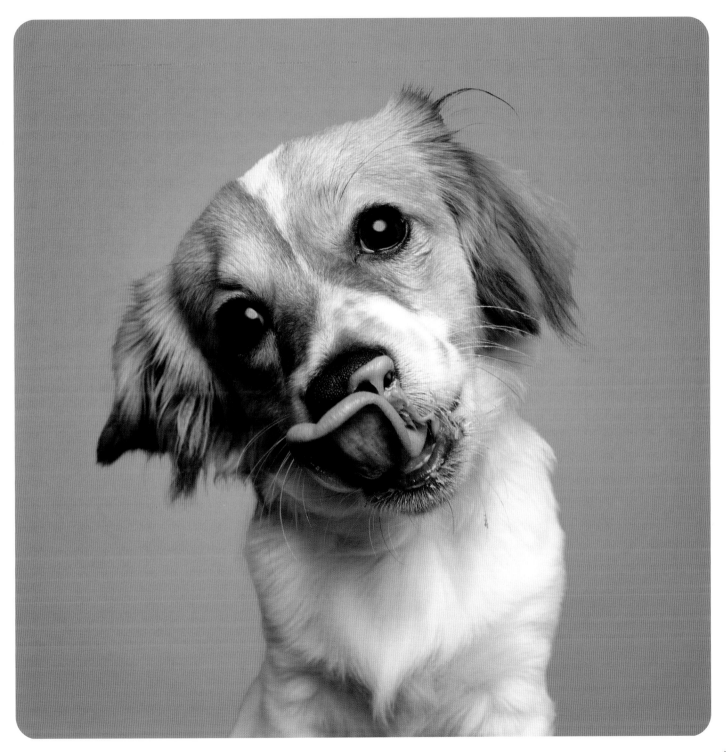

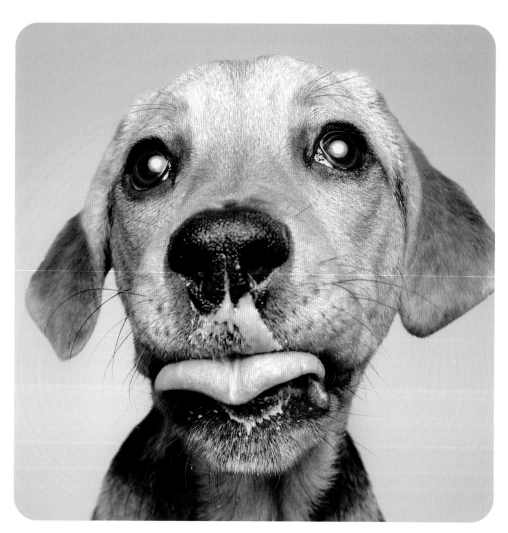

MAGGIE
7 months
Shepherd mix

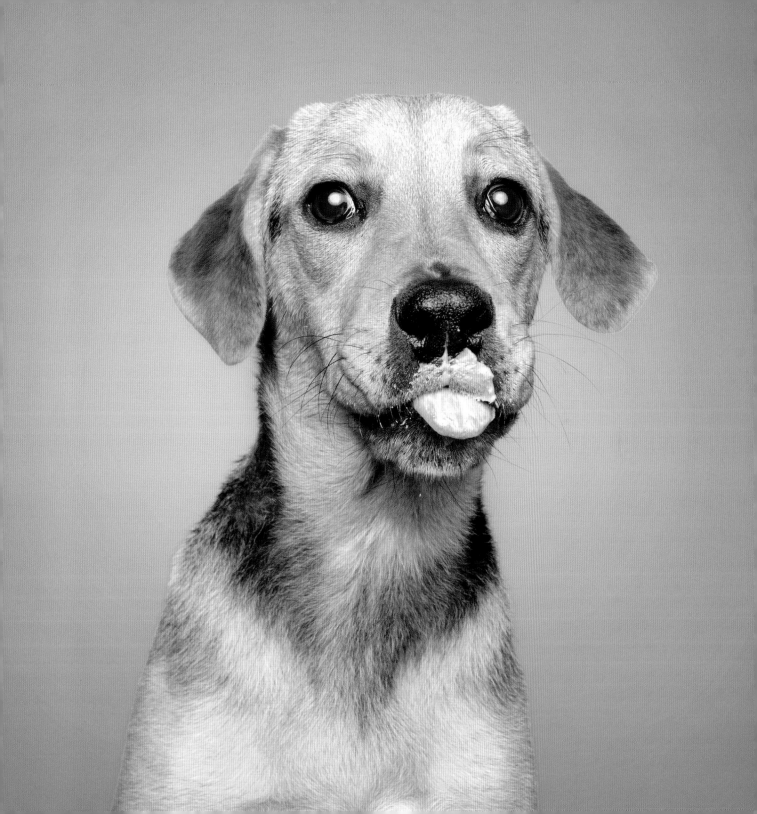

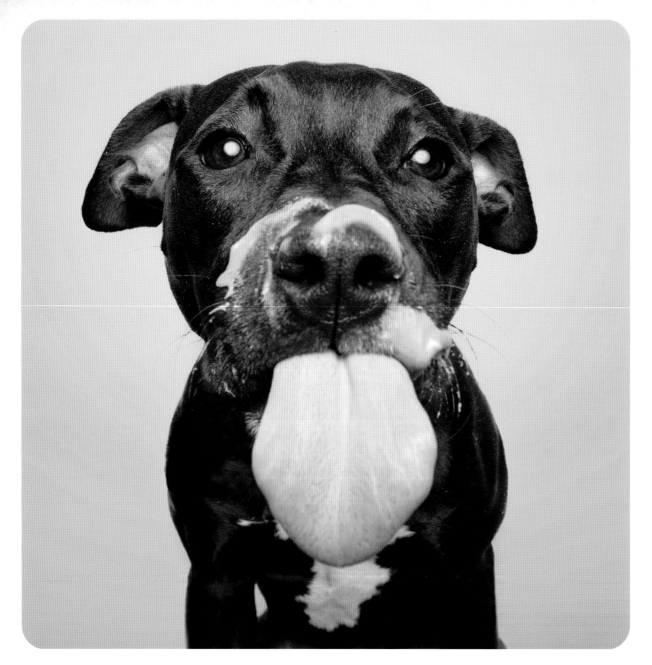

NESSA
8 months
Pit bull mix

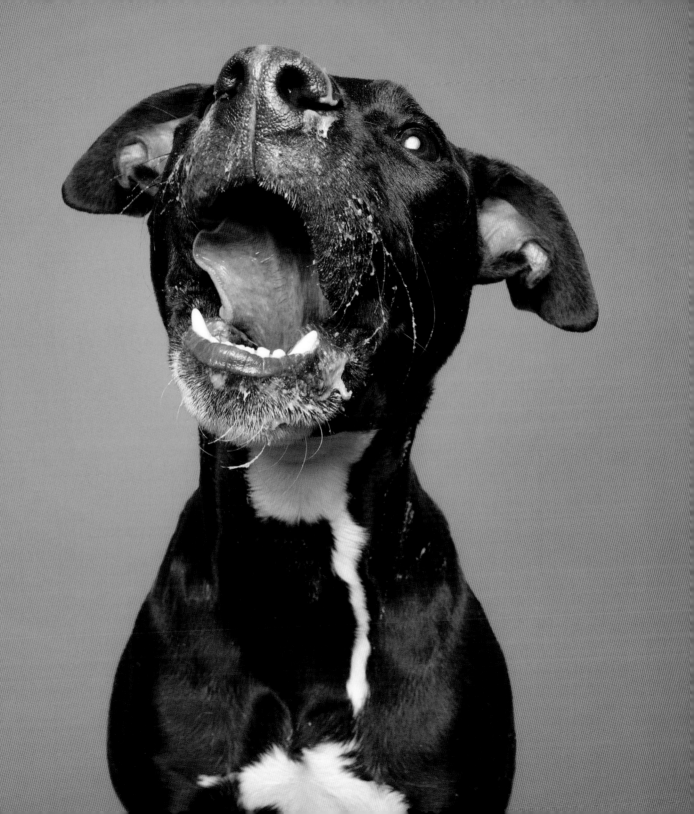

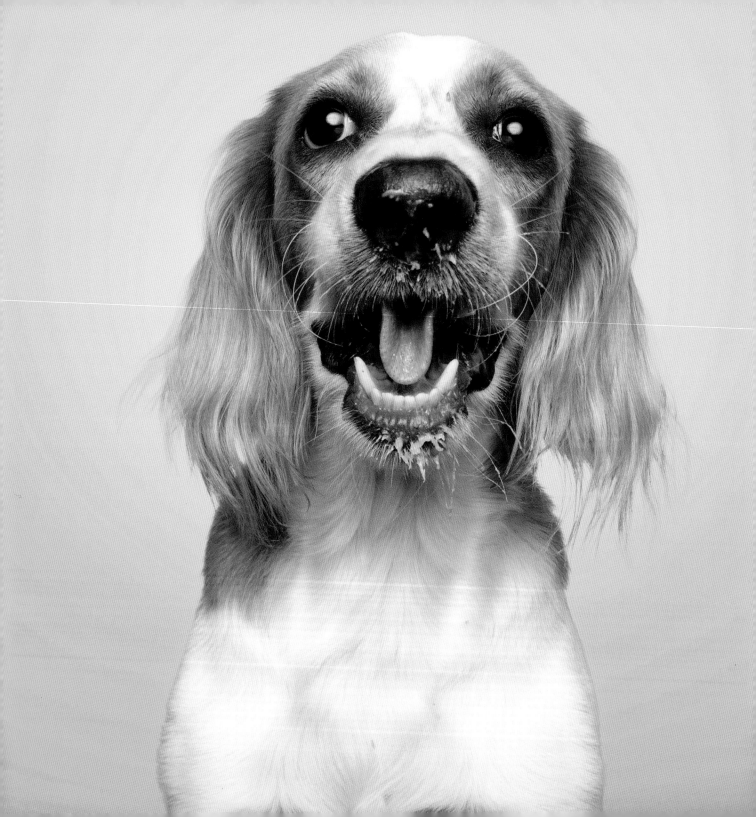

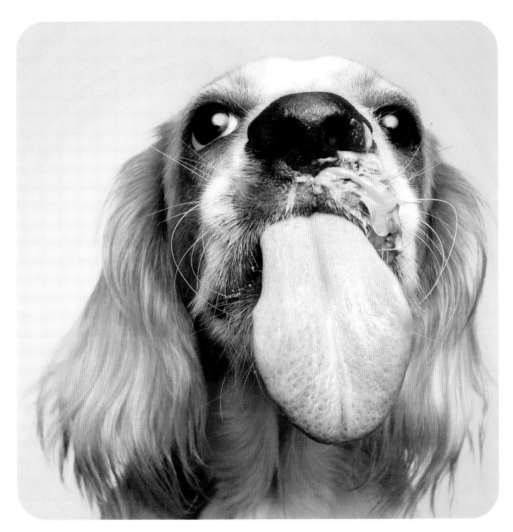

LUCY
5 months
King Charles cavalier/
hound mix

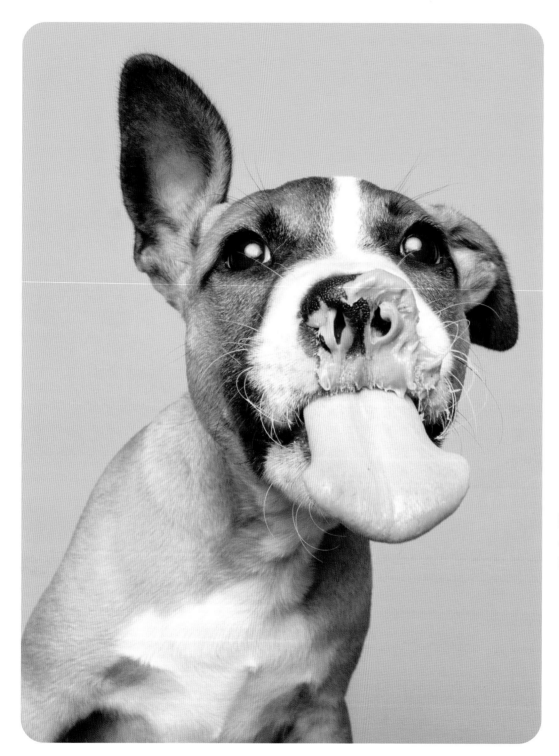

ECHO
4 months
Boxer mix

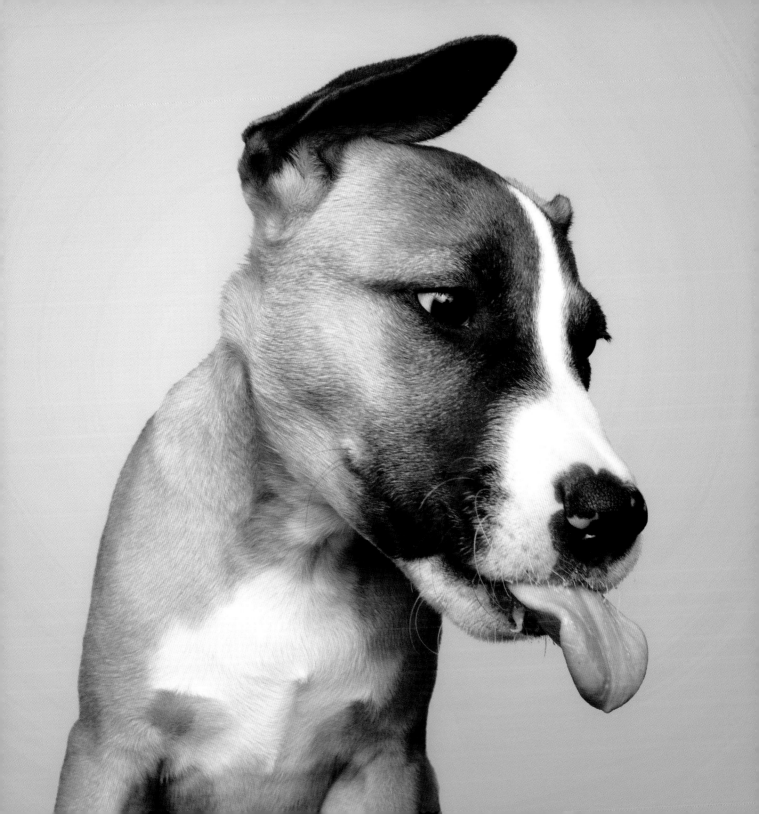

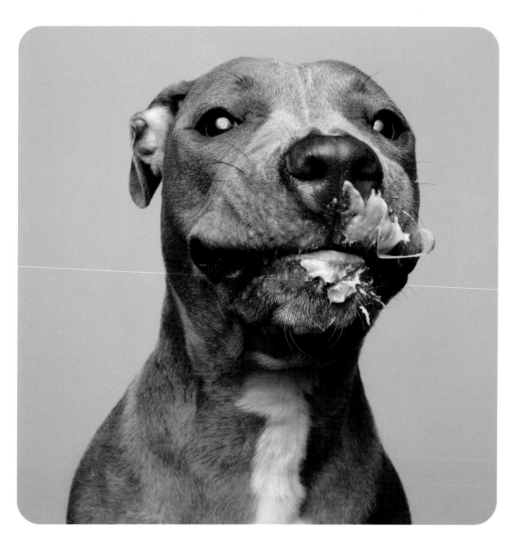

SUNNY
10 months
Pit bull mix

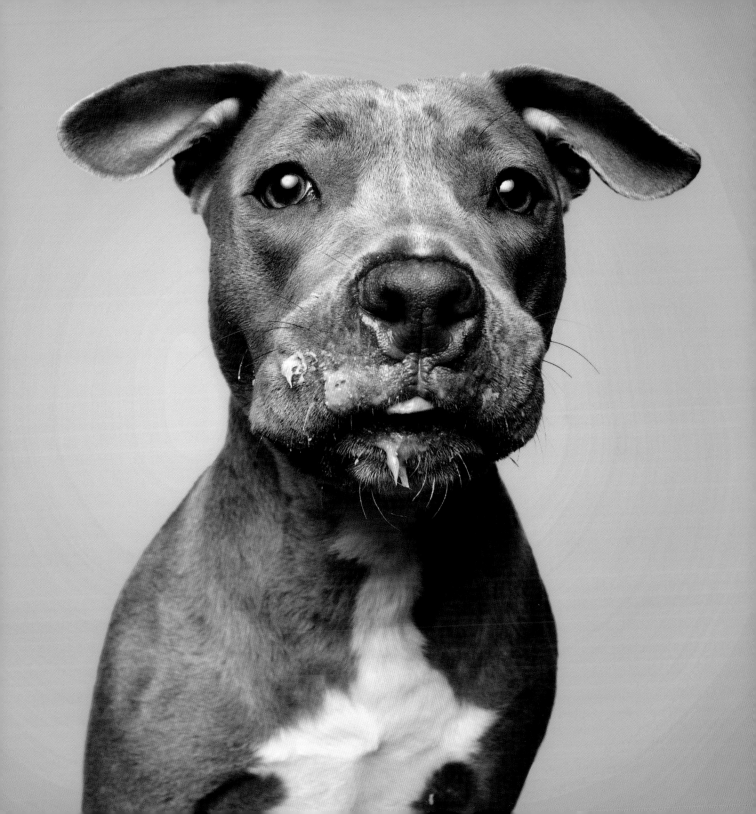

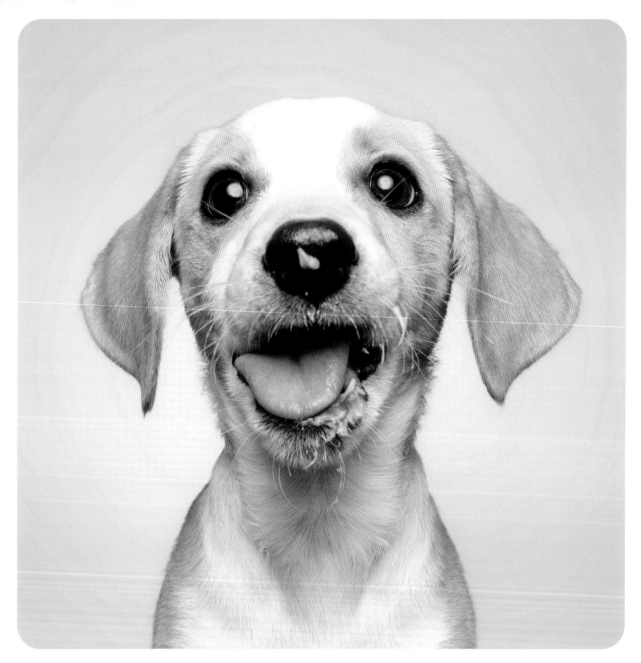

COOPER
3 months
Beagle/dachshund mix

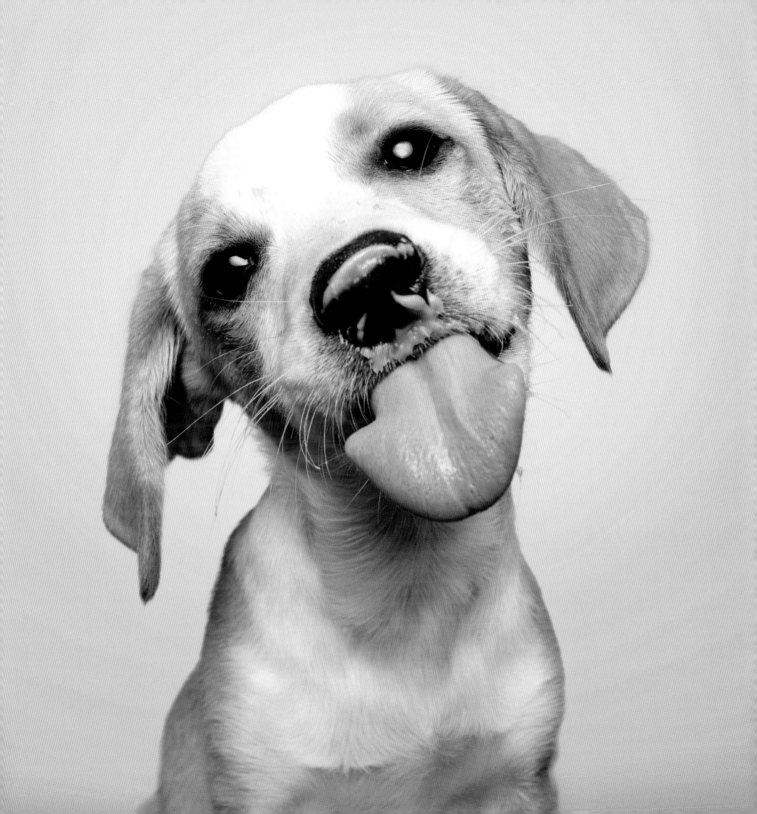

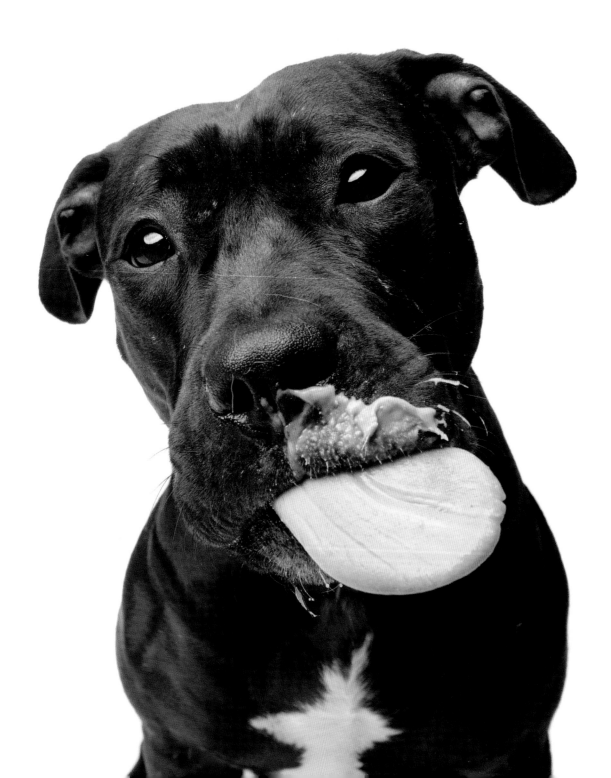

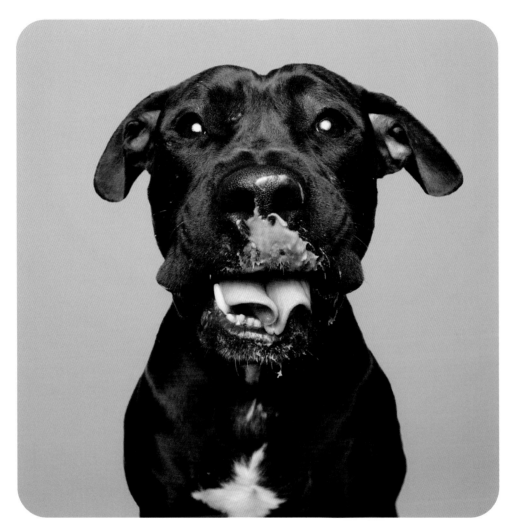

HARLEY
1 year
Pit bull mix

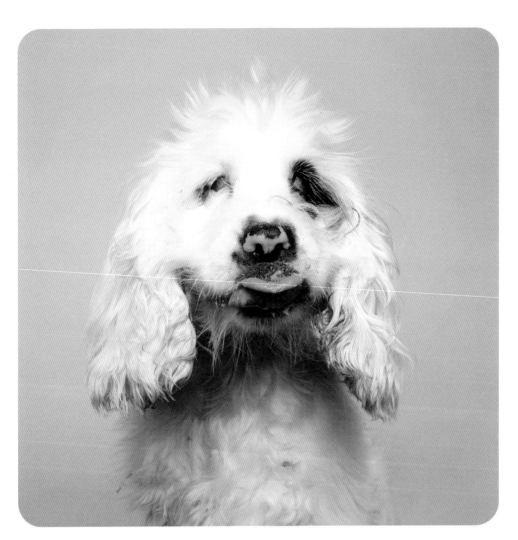

BELLE
6 months
Cocker spaniel

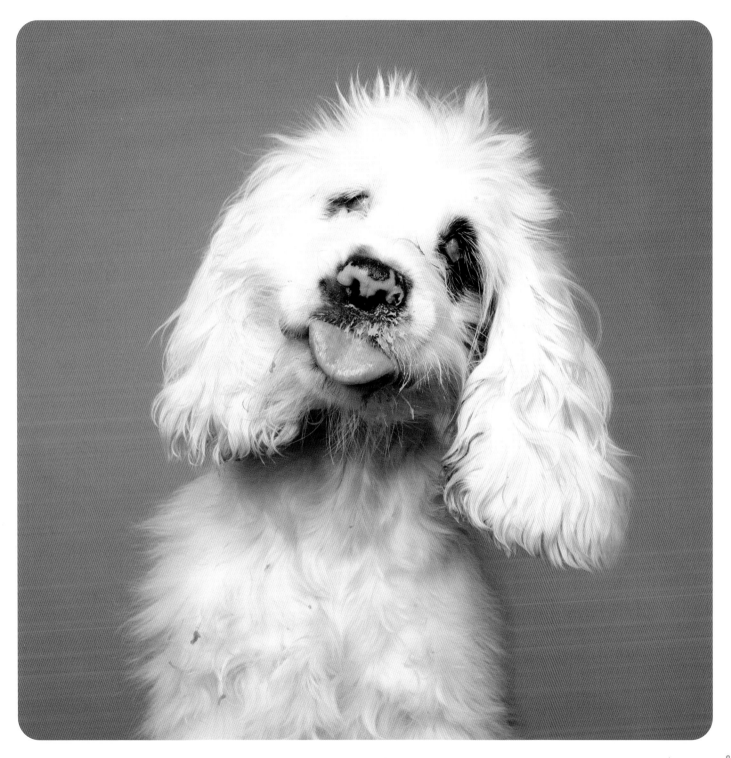

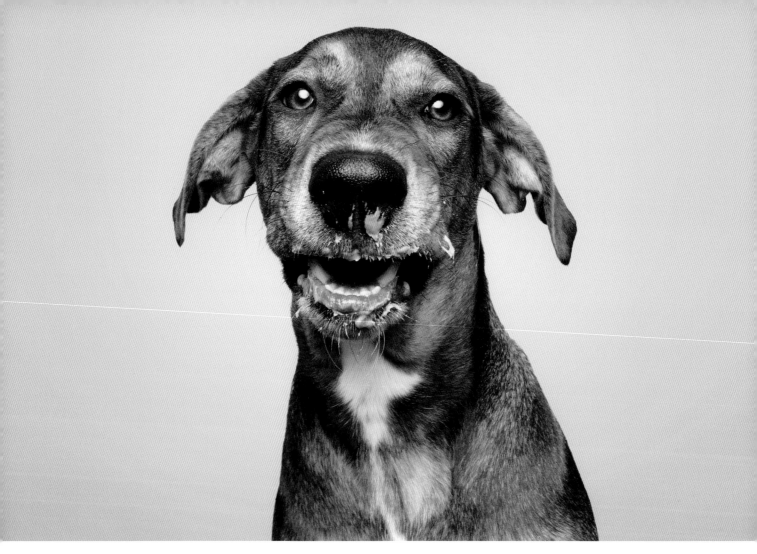

ROSCOE
7 months
Shepherd/hound mix

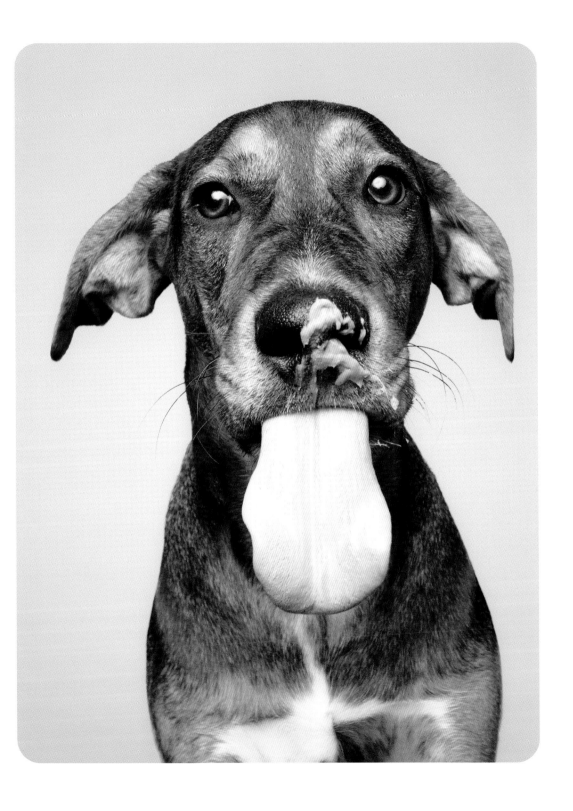

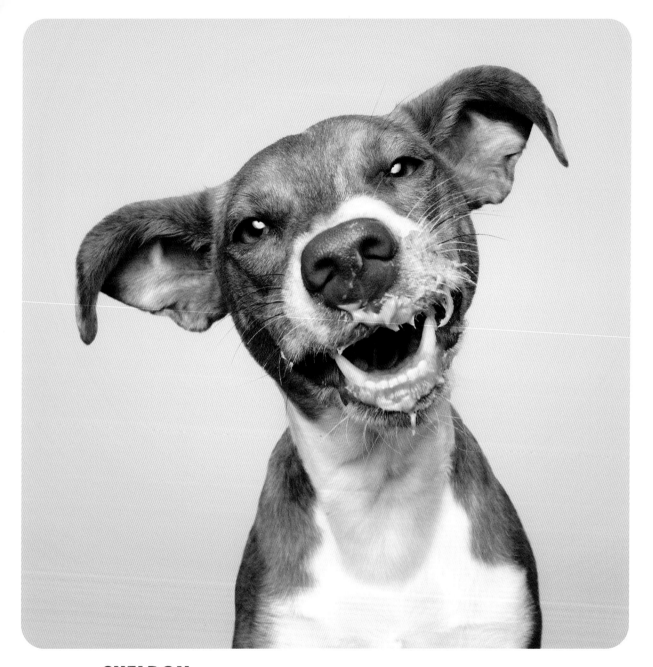

SHELDON
1 year
Shetland sheepdog/
pit bull mix

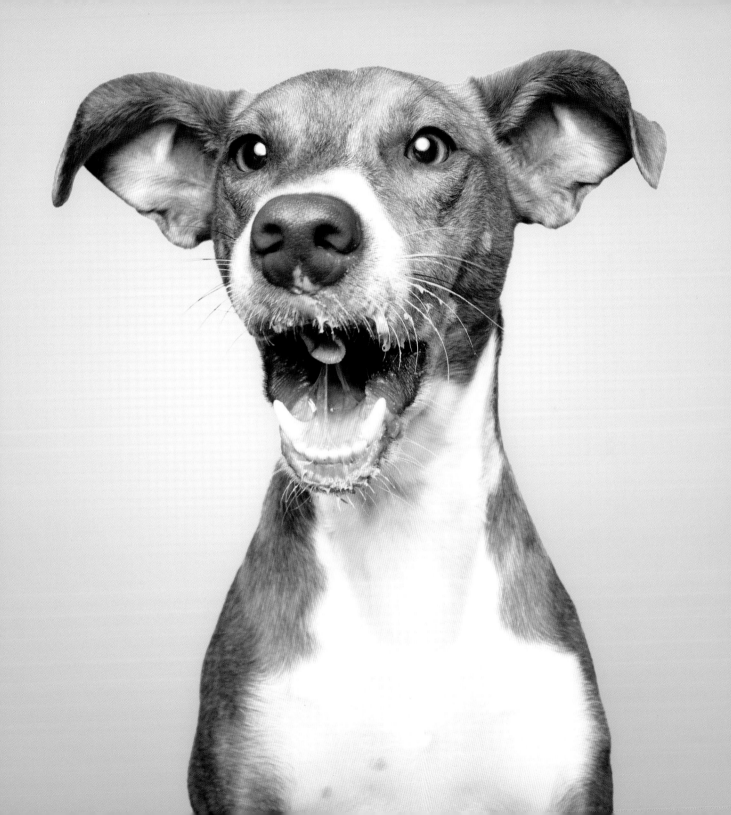

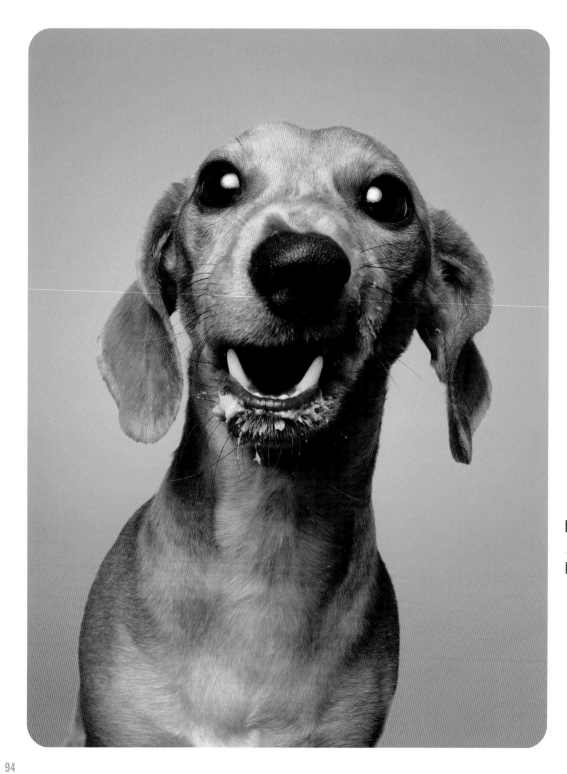

LILY
1 year
Dachshund

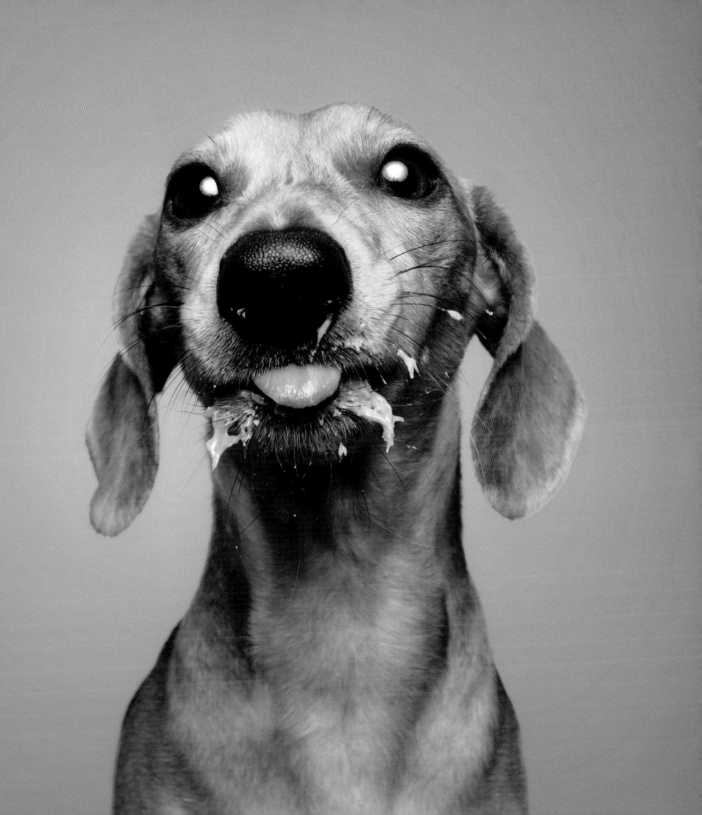

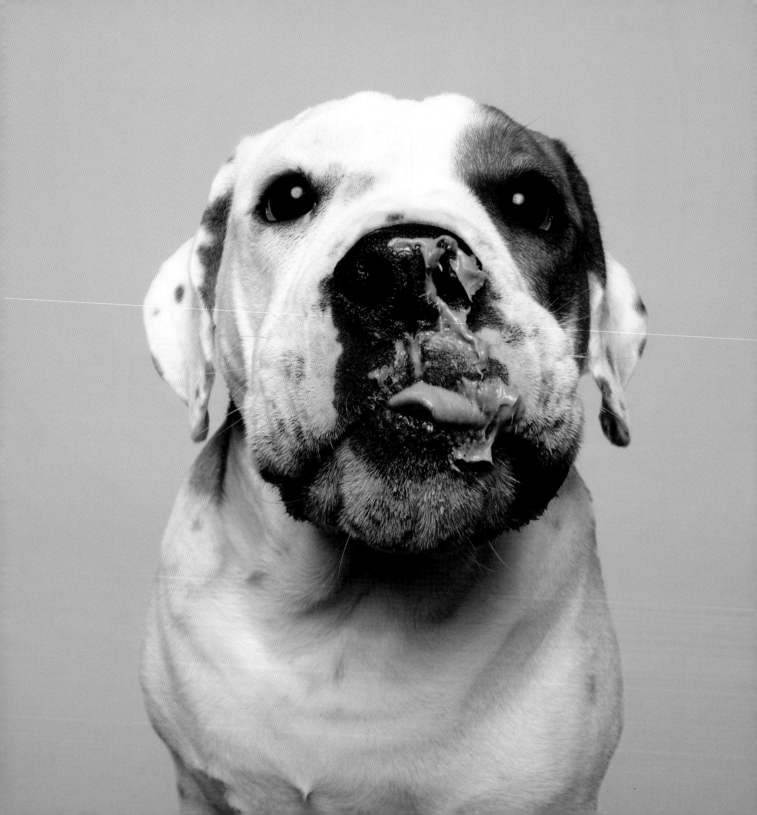

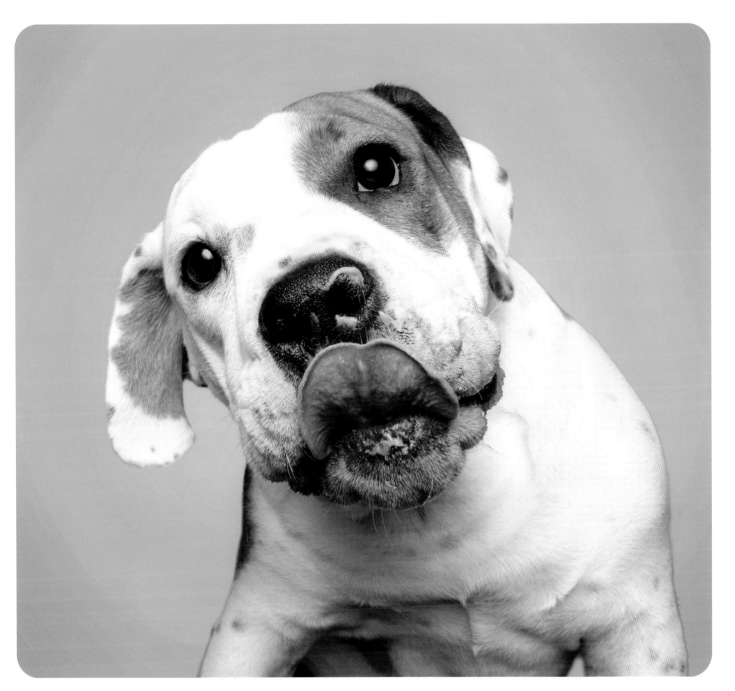

BUMBLE
10 months
Beagle/bulldog mix

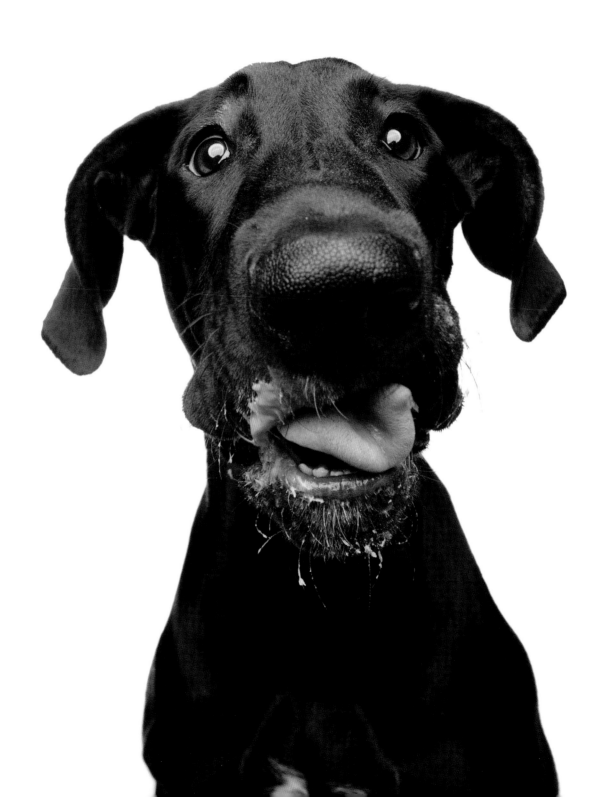

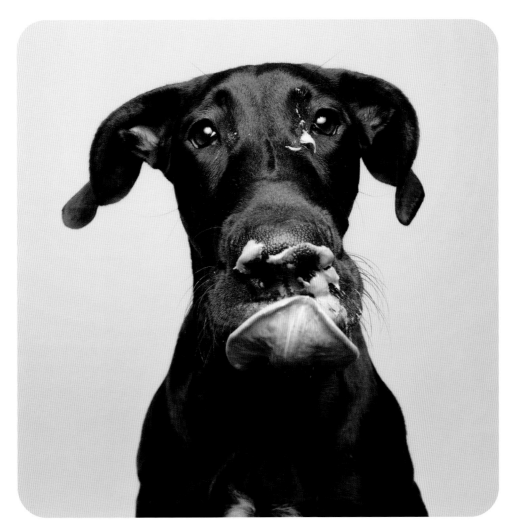

EVE
6 months
Great Dane

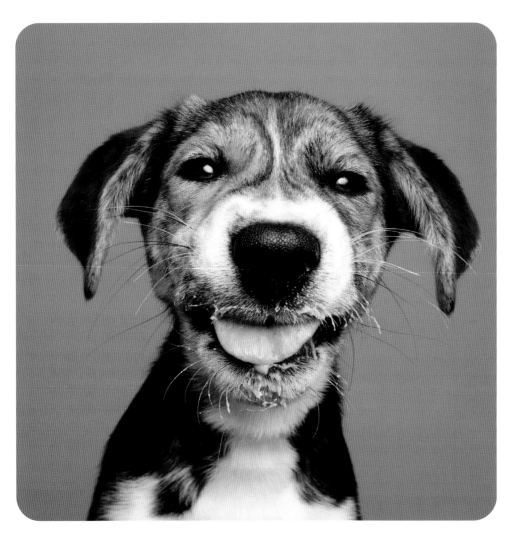

THALIA
3 months
Beagle/shepherd mix

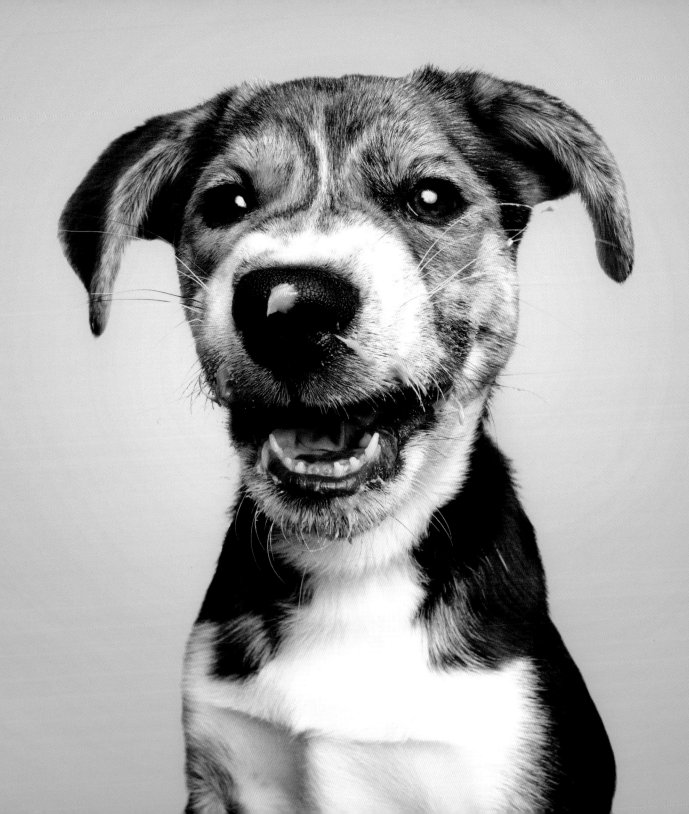

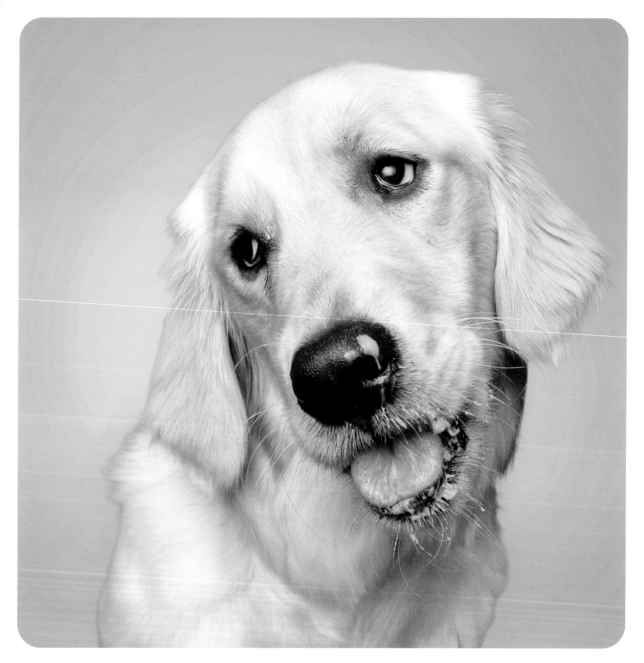

GINNY
7 months
Golden retriever

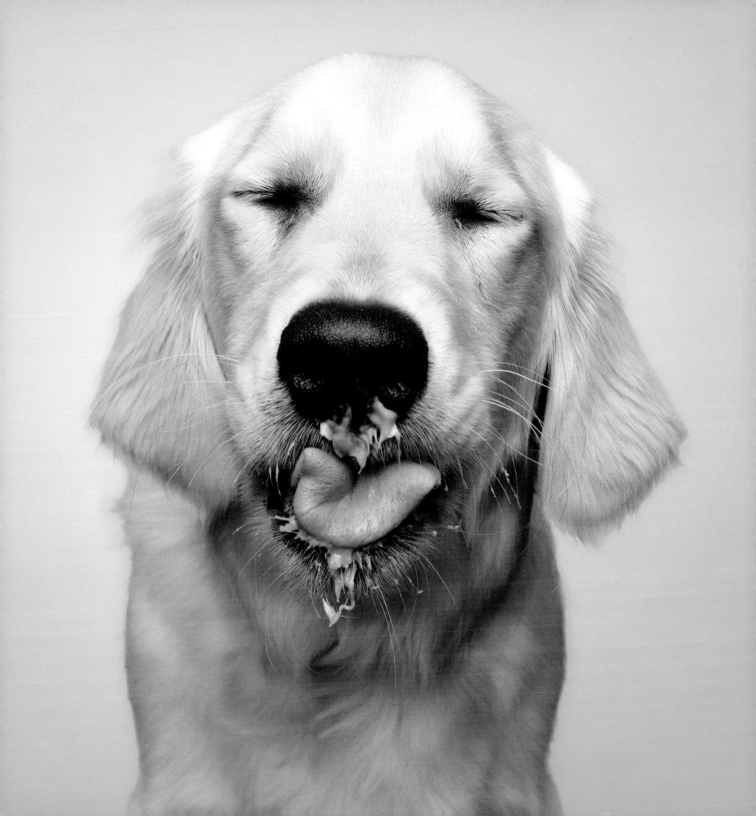

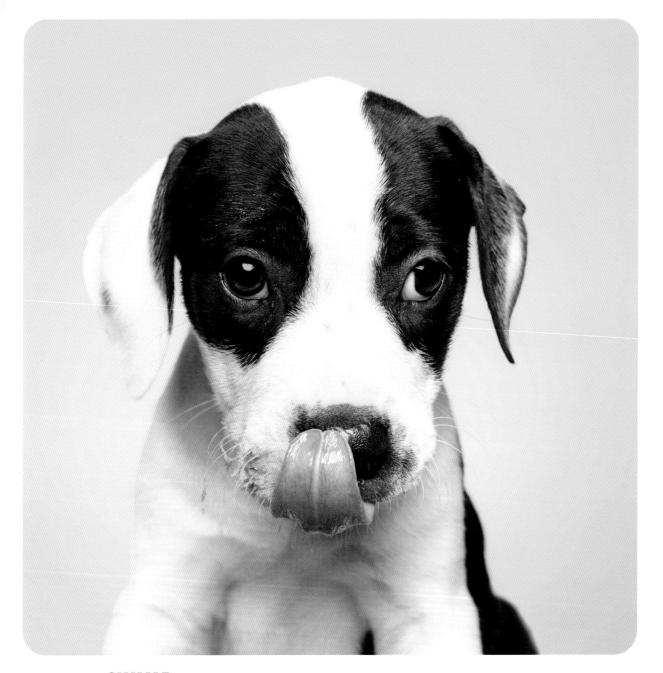

CHUMP
9 weeks
Pit bull mix

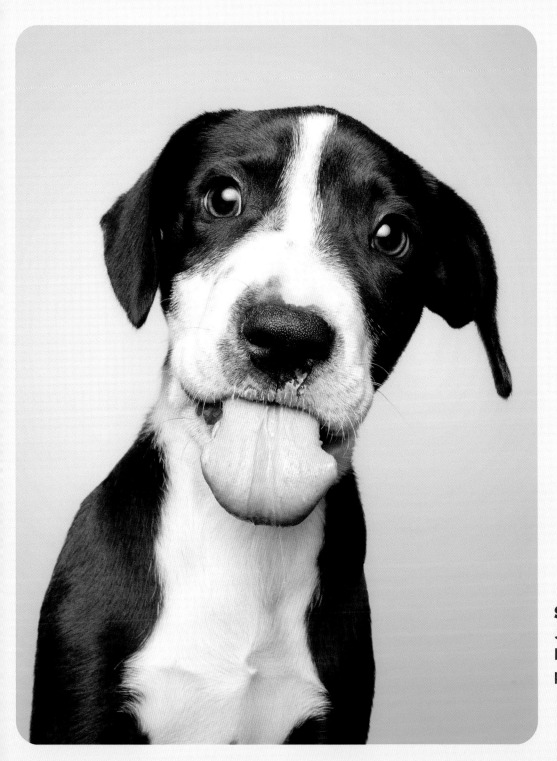

SEAMUS
3 months
Labrador retriever/
pit bull mix

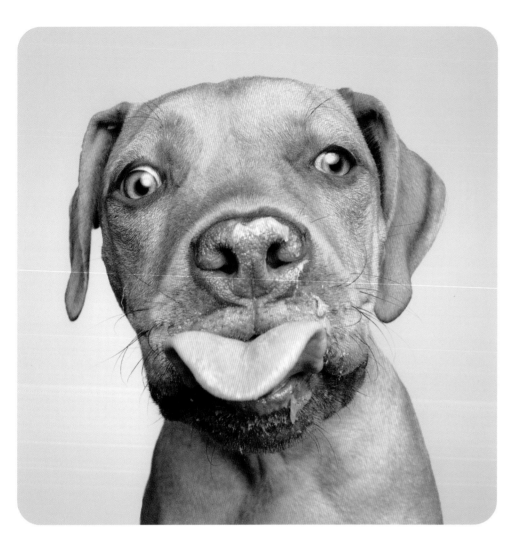

MILLIE GRACE
5 months
Pit bull/mastiff mix

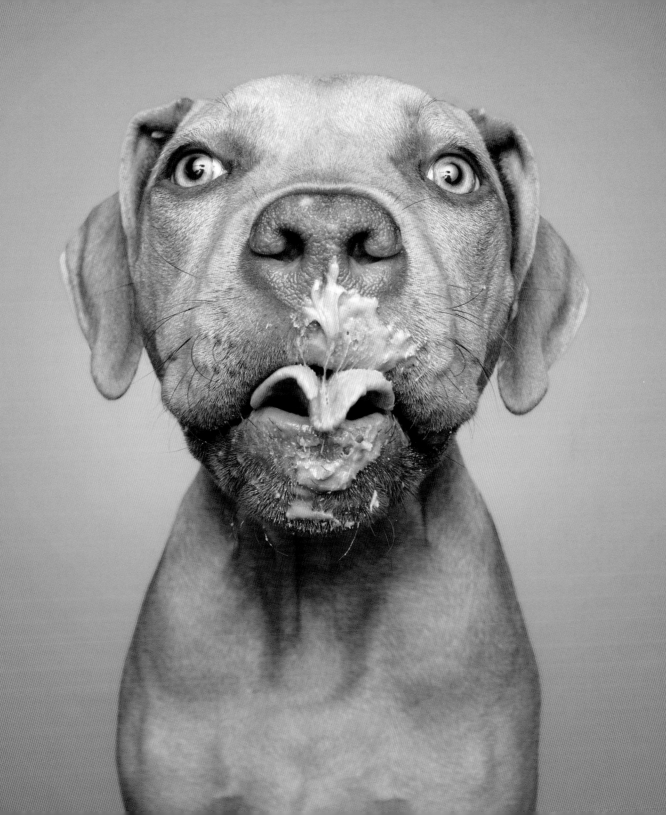

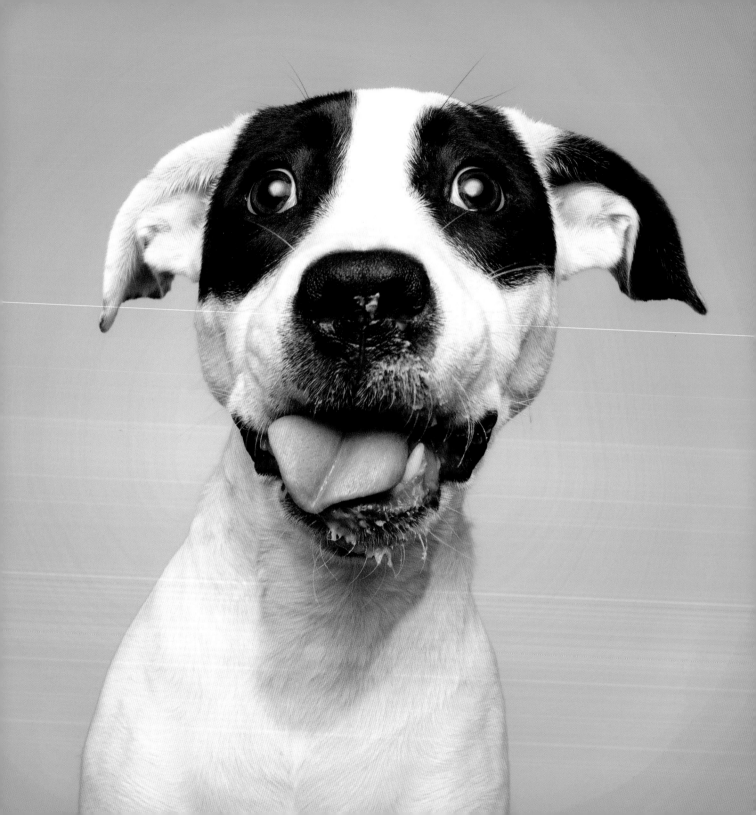

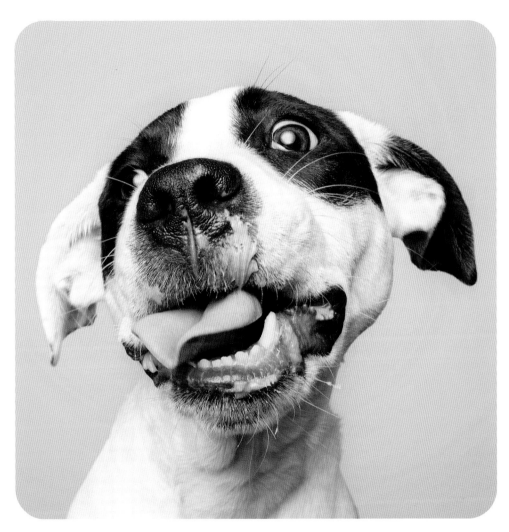

FREYA
5 months
American bulldog mix

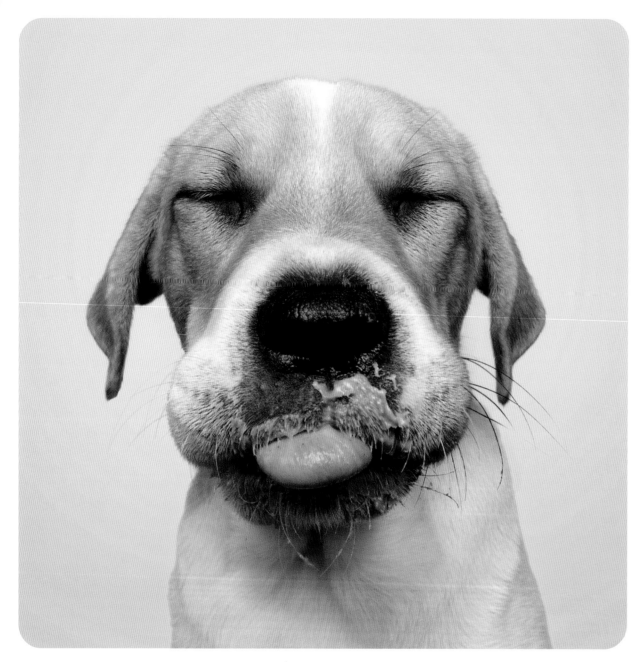

OCIE
6 months
Pit bull/shar-pei mix

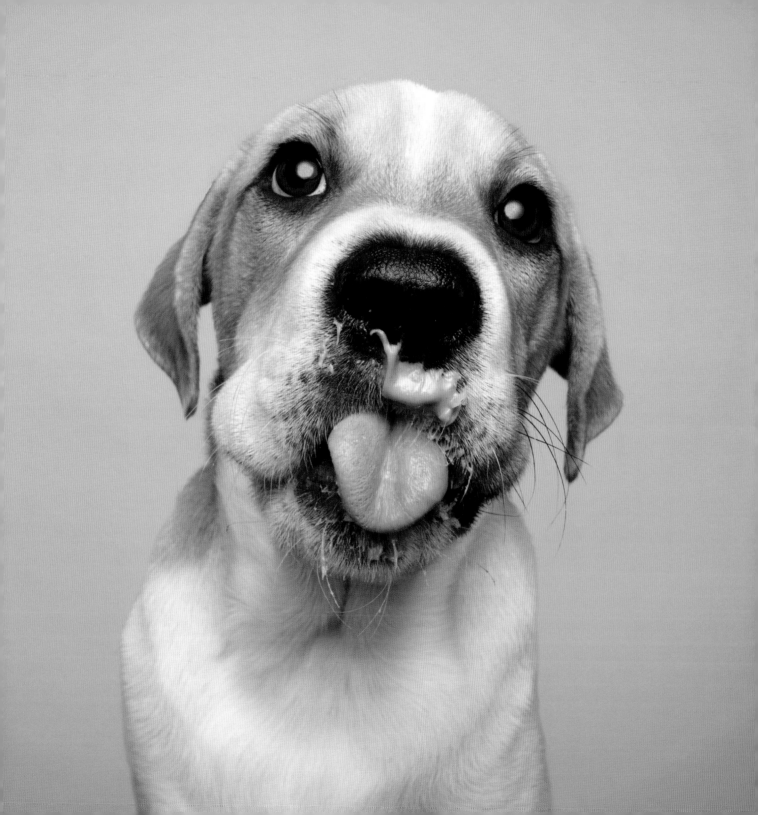

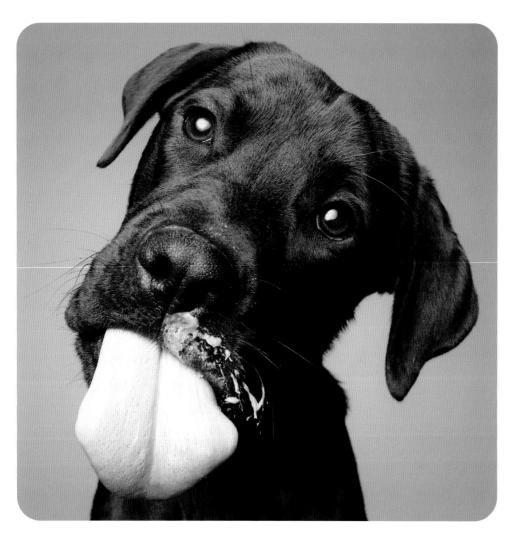

CHUBBS
8 months
Labrador retriever mix

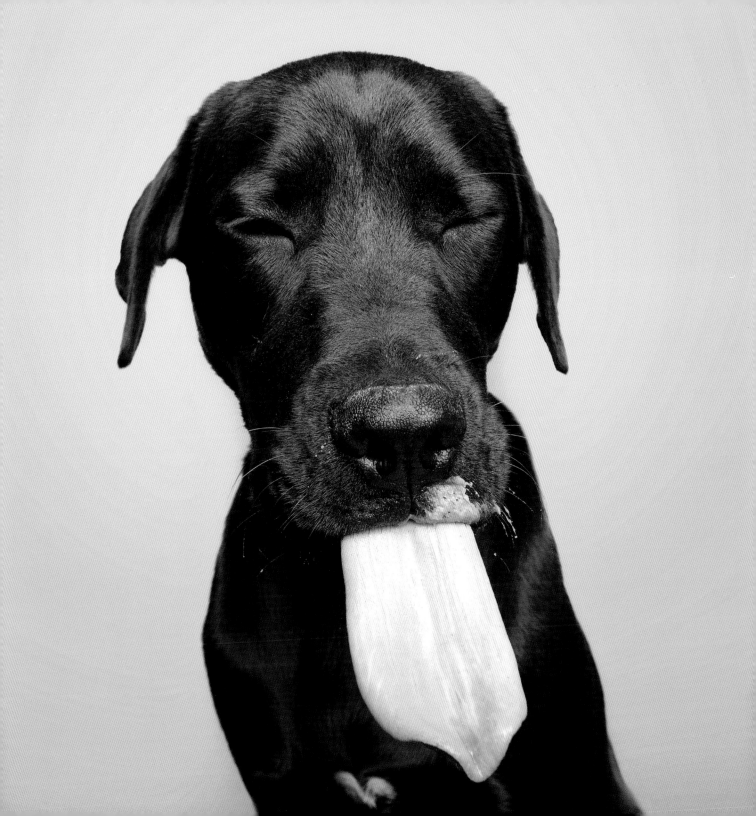

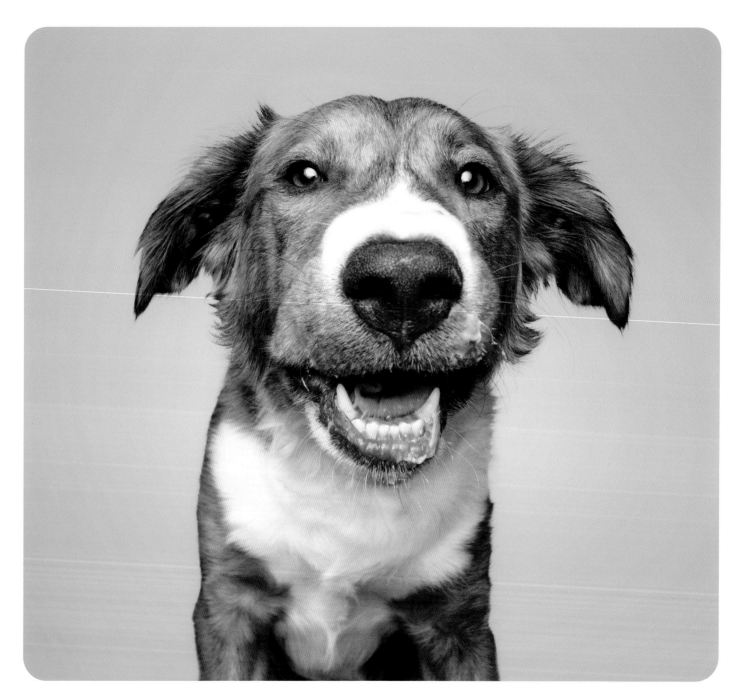

ZION
6 months
Pit bull/border collie mix

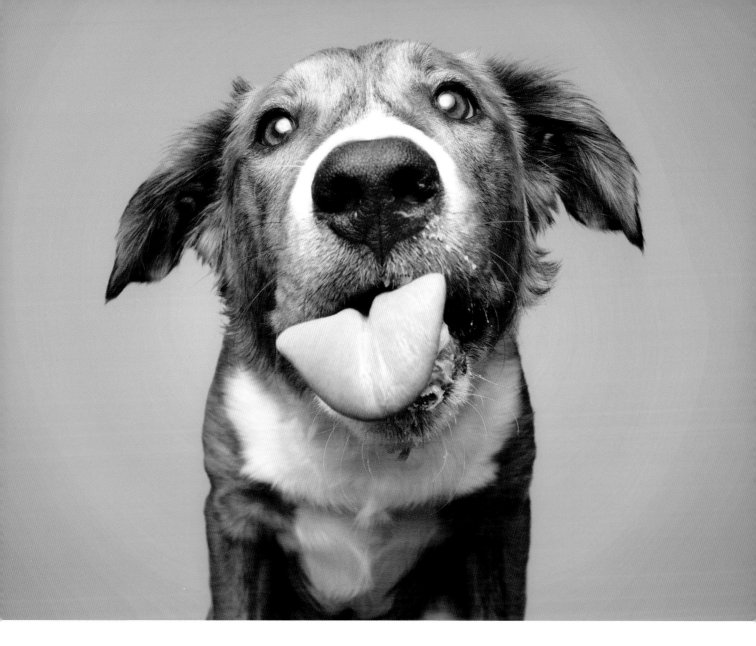

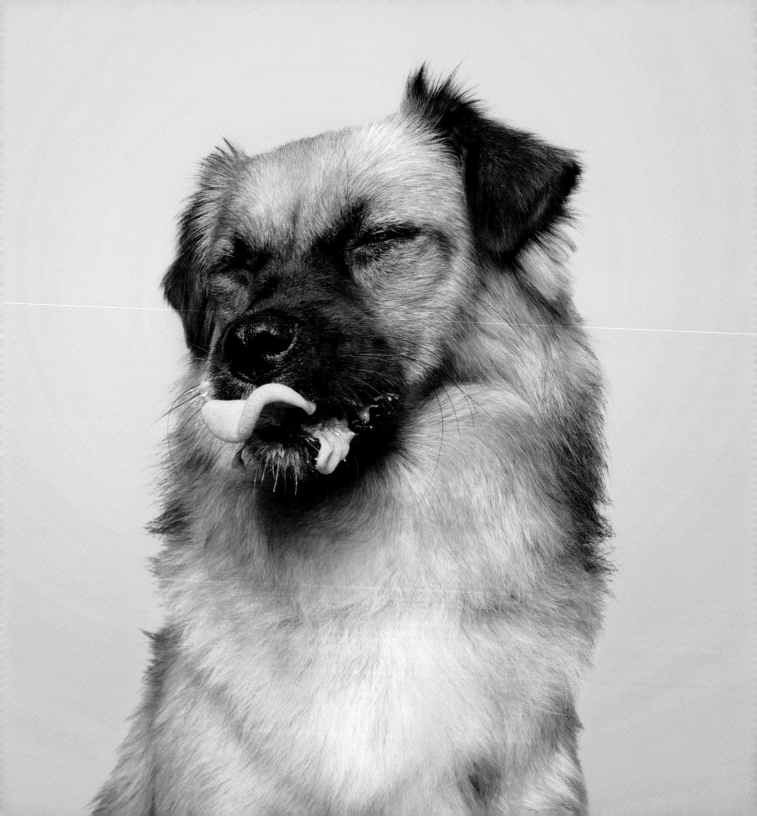

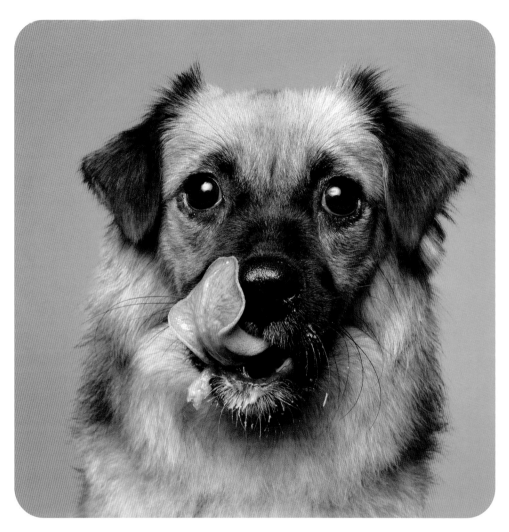

MORCHELLA
8 months
Pekingese/Jack Russell terrier mix

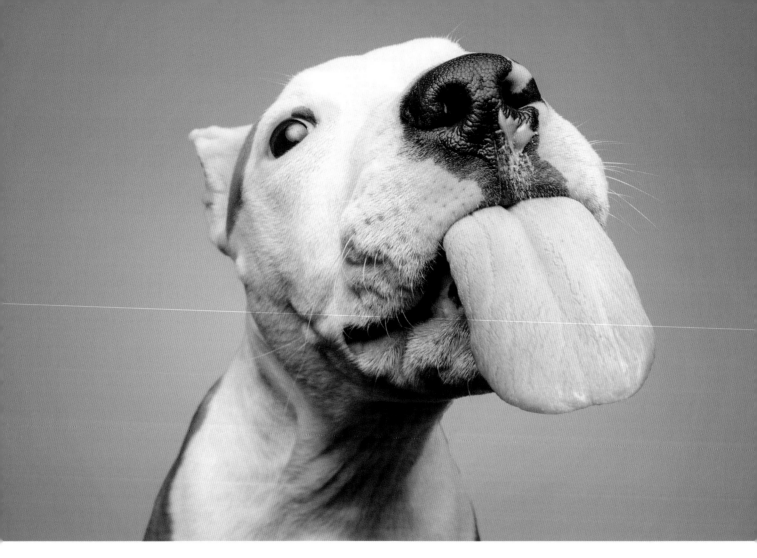

RUPERT
4 months
Pit bull mix

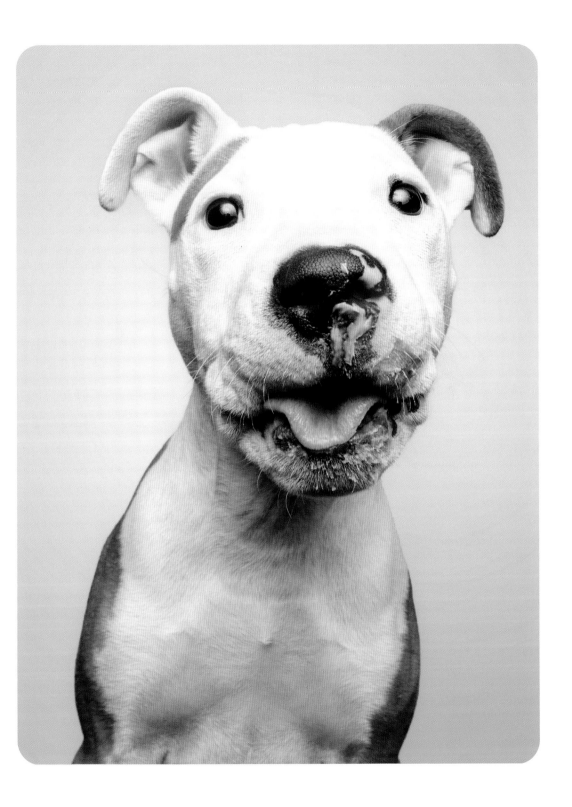

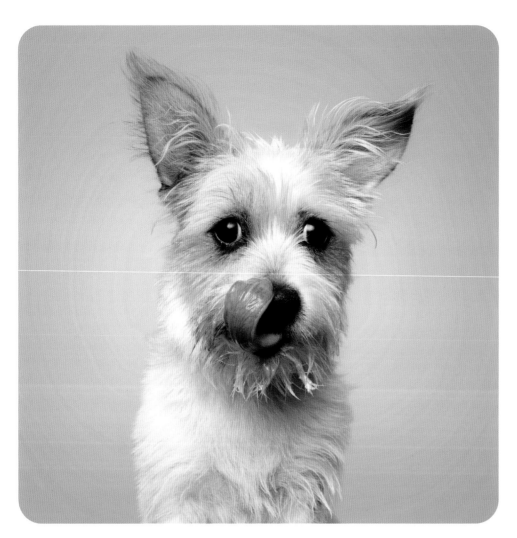

DINKERS
7 months
Shih tzu mix

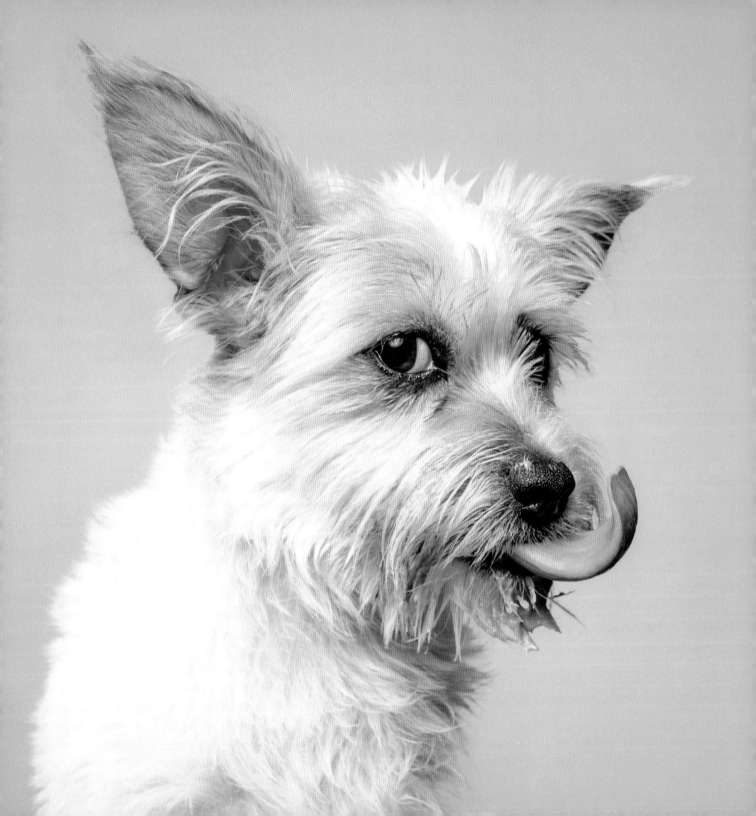

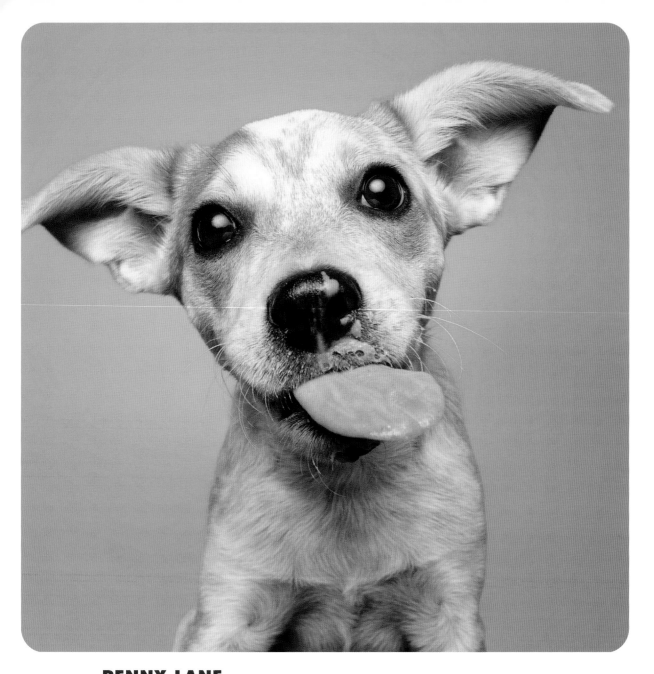

PENNY LANE
4 months
"Red heeler" Australian cattle dog mix

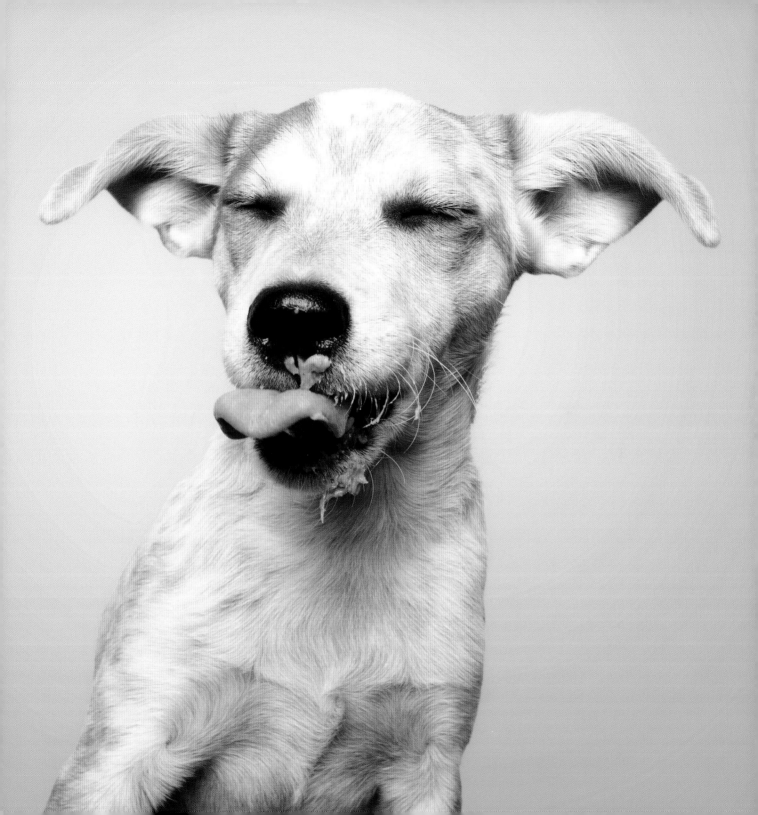

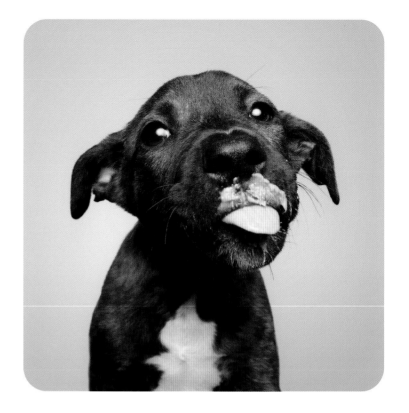

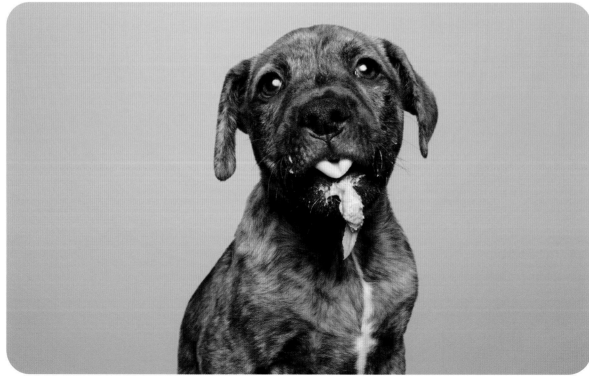

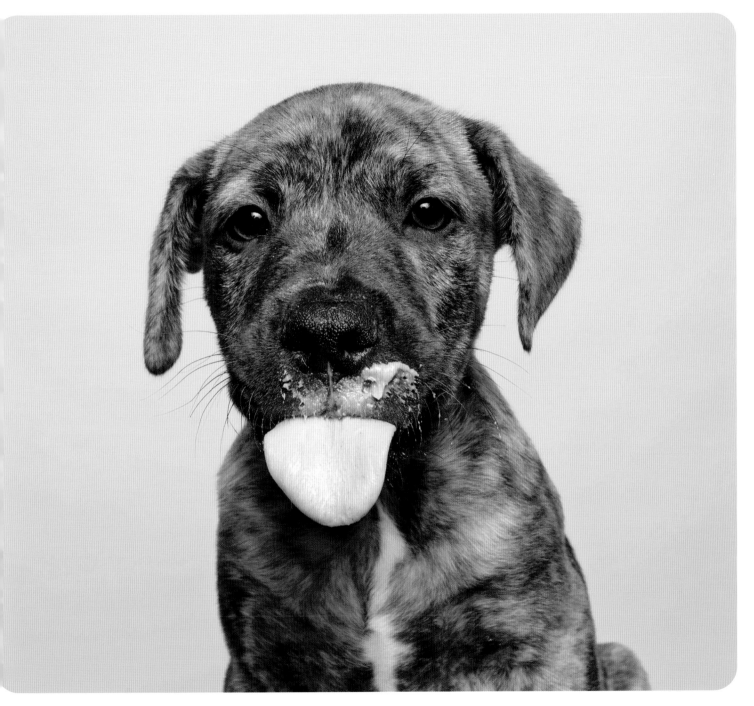

CAT & NICKS
8 weeks
Labrador/pit bull mixes

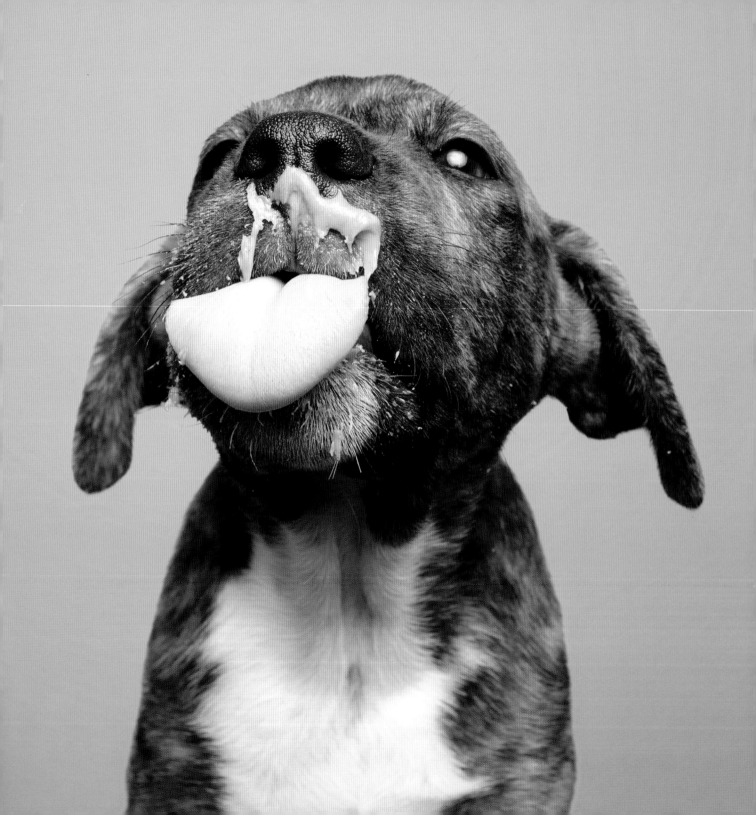

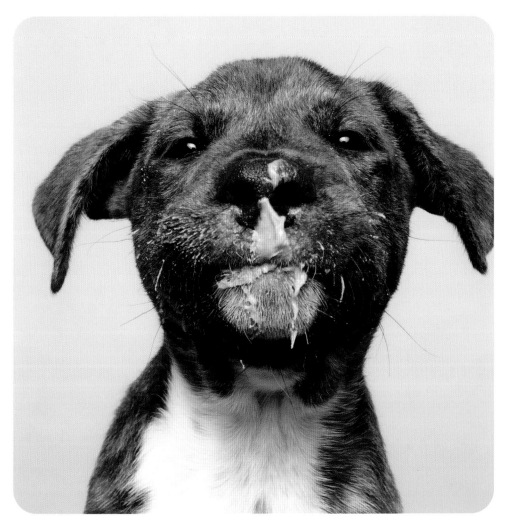

PERRY
8 weeks
Labrador/pit bull mix

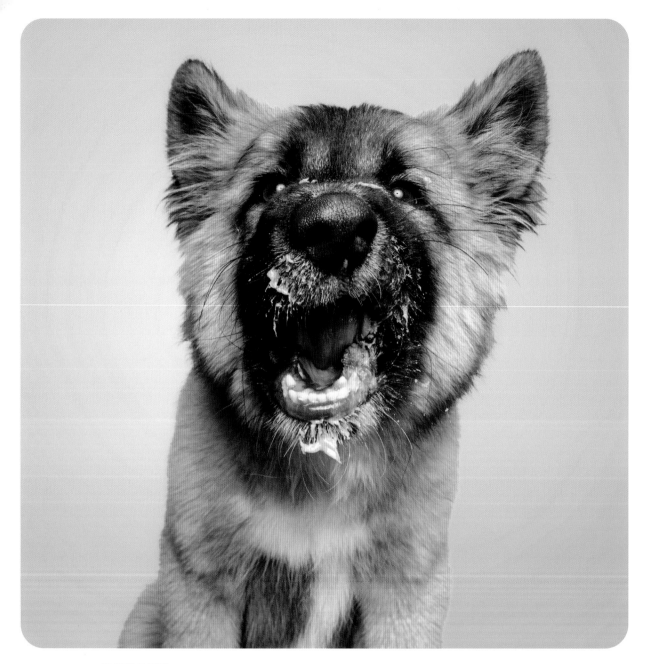

BULLET
5 months
German shepherd mix

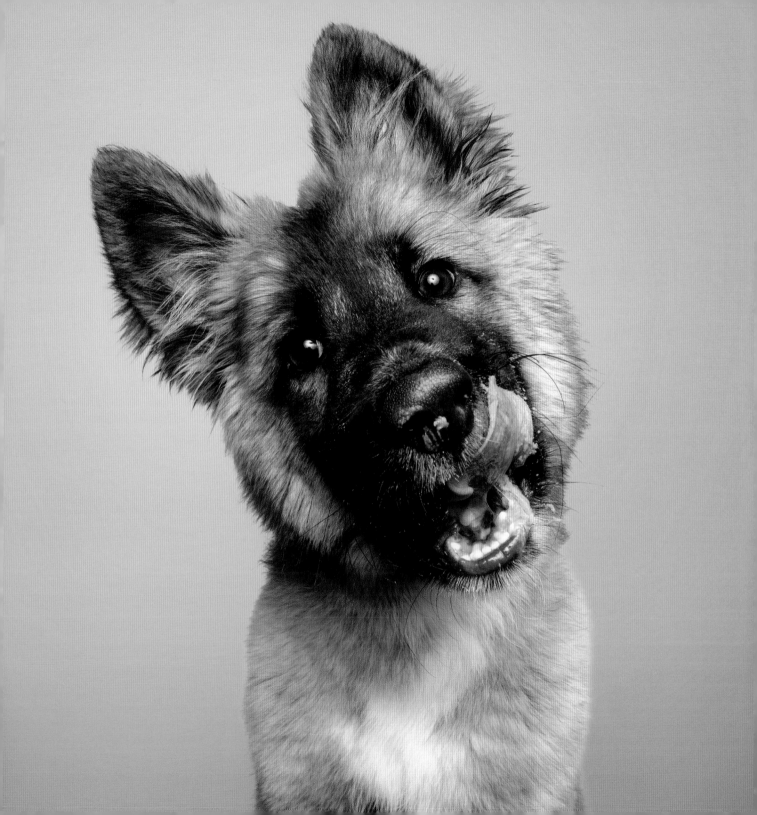

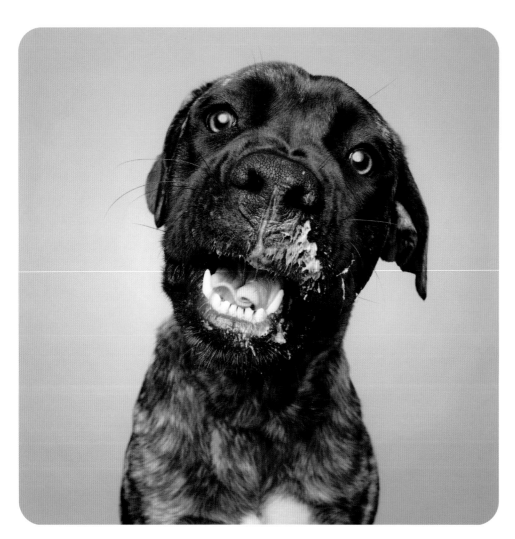

LUNA
6 months
Cane corso

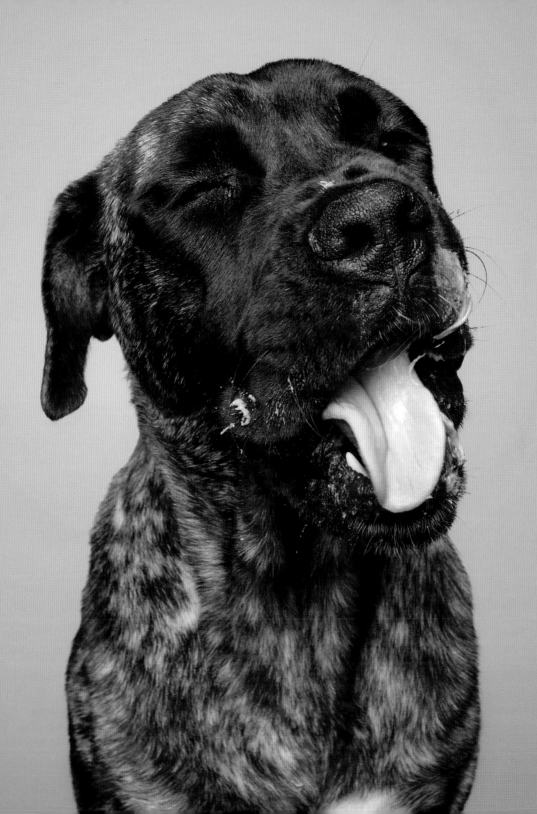

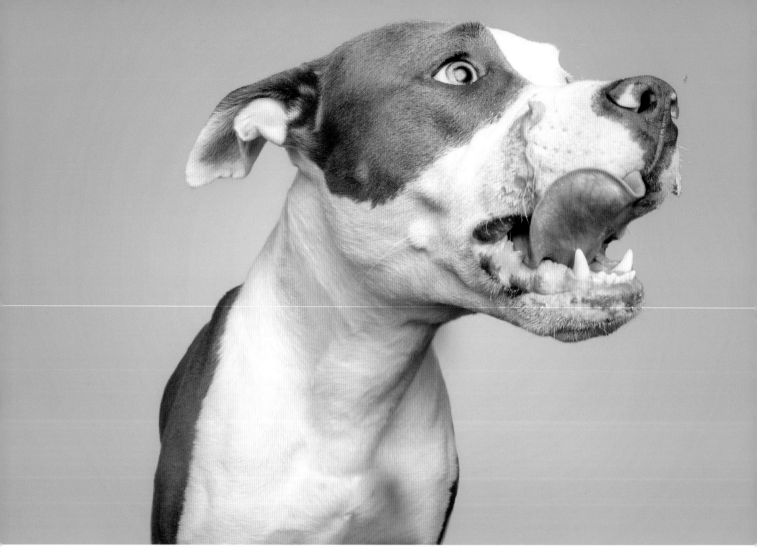

RORY PICKLES
1 year
Pit bull mix

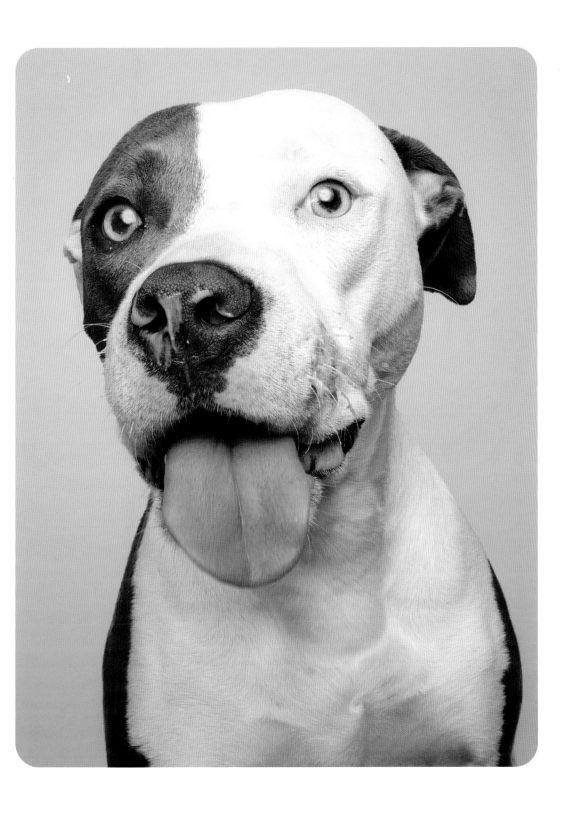

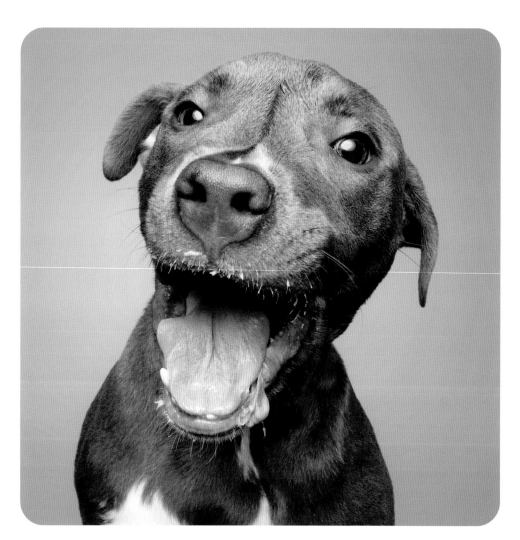

ROXY
6 months
Pit bull mix

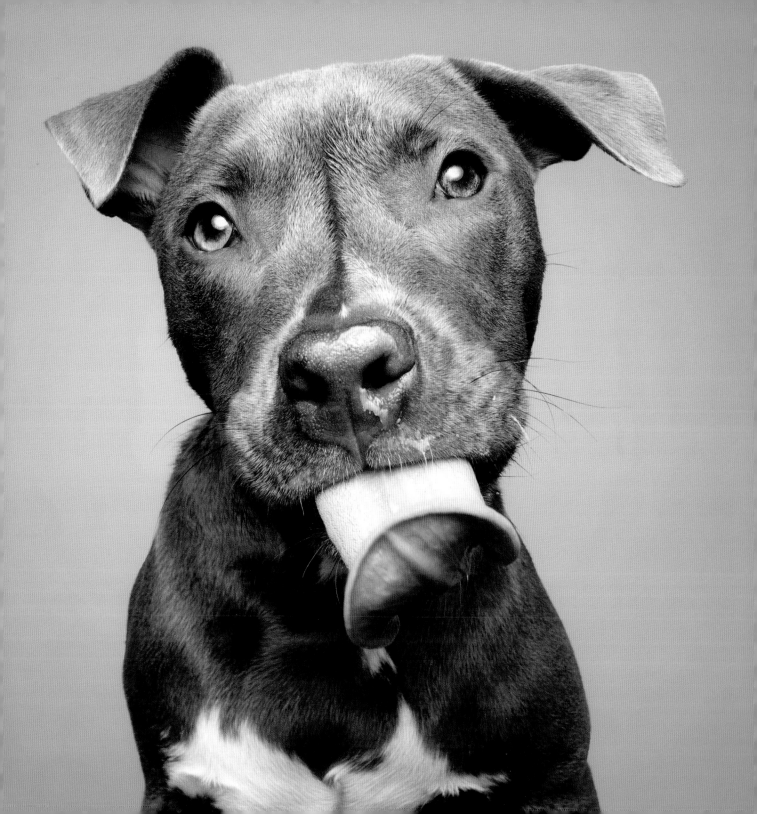

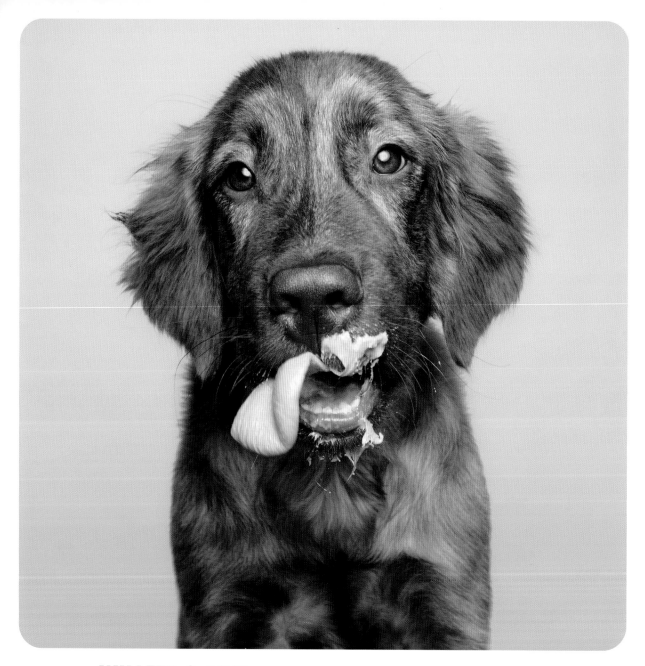

WILLETT & LILY
4 months
Saint Bernard/retriever mixes

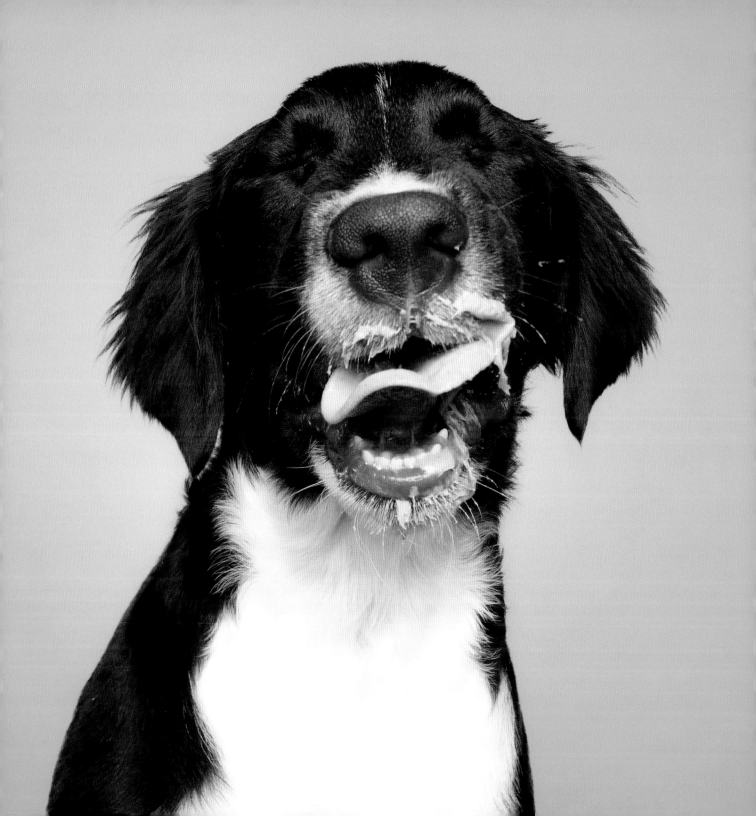

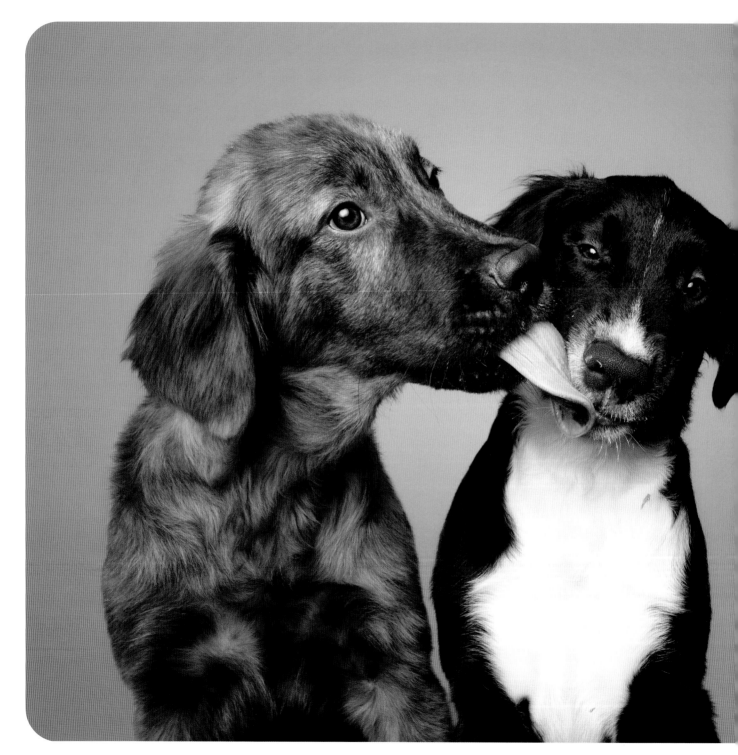

DISCLAIMER

Please note the following about dogs and peanut butter before you consider giving it to a furry friend of yours:

In most cases, a little bit of peanut butter is perfectly fine for dogs. It's generally safe, and it's even a good source of protein, vitamins, and healthy fats.

Too much of anything, including peanut butter, is not good for dogs. The puppies in this book were only given small amounts of peanut butter during photo shoots.

All-natural peanut butter, made up of peanuts and salt, is ideal. Avoid any peanut butter that contains xylitol. Xylitol can be very dangerous to dogs. ALWAYS check labels before giving any type of food to your dog.

Consider consulting your veterinarian prior to giving peanut butter to your dog(s). Just like with humans, a few dogs may have peanut allergies even though most dogs have no problems with peanuts. If your dog appears to have a bad reaction to eating peanuts at any time, contact your vet immediately.

ACKNOWLEDGMENTS

Thank you to everyone who brought in their
amazing rescue puppies to be part of this book.
Thank you to my family, especially Kristen,
Evie, Leo, and Kensie.

LEO & KENSIE

140

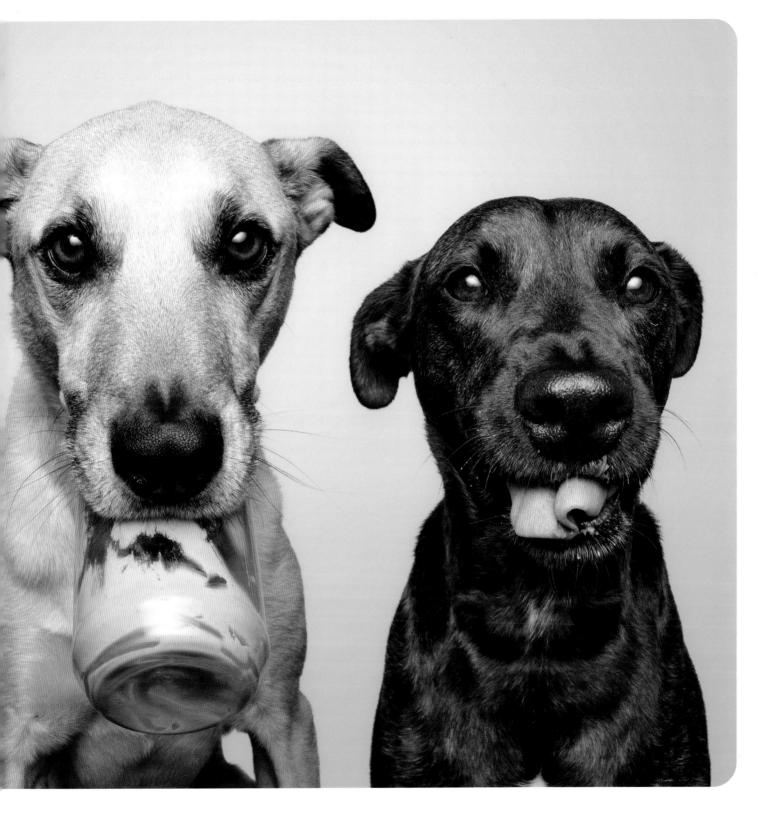

© Kayla Lupean

ABOUT THE AUTHOR

Greg Murray is a commercial, lifestyle, and portrait animal photographer based out of Cleveland, Ohio. After getting his degree in business from Loyola University Chicago and spending ten years in the corporate world as an HR professional, Greg left the field and followed his dream of becoming a full-time pet photographer. He is the author/photographer of *Peanut Butter Dogs* (2017) and *Pit Bull Heroes: 49 Underdogs with Resilience & Heart* (2019). Greg is a rescue animal and pit bull–type dog advocate who in 2018, along with many more dedicated advocates, helped to end a ten-year ban on pit bull–type dogs in his hometown of Lakewood, Ohio. He lives in Lakewood with his wife, Kristen, their daughter, Evie, and their two rescue dogs, Leo and Kensie.

@thegregmurray | Greg Murray Photography | www.gmurrayphoto.com

ALSO AVAILABLE,
WHEREVER BOOKS ARE SOLD!

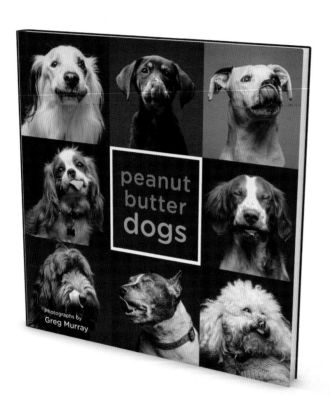

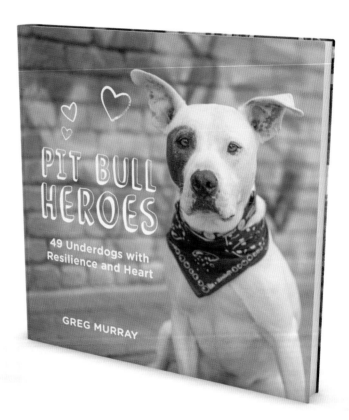